YOU ARE A WRITER

(so start ACTING like one)

JEFF GOINS

YOU ARE A WRITER

(so start ACTING like one)

JEFF GOINS

You Are a Writer (So Start ACTING Like One)

TABLE *of* CONTENTS

INTRODUCTION

Hi. My name's Jeff. And I'm a writer.

Like most writers, I like to write. Not sell myself, or pitch ideas, or wait for publishers to pick me. Just *write*.

I've stumbled upon this idea, you see, that writers shouldn't spend all their time doing what they don't enjoy. Instead, they need to do what they love. They need to write.

Sounds idealistic, right? But this is the key to creating your best work. And even though it runs counter to what we might think, this is also the key to finding the readers who will love that work.

So how do you "just write"? I mean, let's be honest. We've all heard how writers need platforms and influence and great marketing, right?

But how do you find the sweet spot where your best writing does this for you?

That's what this book is about. It's about falling back in love with your craft *and* building a platform to share your work, so you don't have to become a sleazeball who's constantly pitching or selling yourself.

Instead, you can focus on what you were made to do: write.

THE LONGING

Cole Bradburn is a chiropractor who longs to be a poet.

Most days, he works in an office, helping people improve their health. Secretly, though, he longs to make a difference with his words. "Someday," he hopes. "Maybe, if I'm lucky."

It's not that Cole hates his job. He rather likes it. Which is the whole problem. There's another life he longs to live as well, a parallel one that feels at odds with the one he's living.

The world, it seems, is full of people like this. Closet artists and aspiring authors—people longing to do meaningful, inspiring work. There's just one problem: *They're not doing it.*

Many of us worry about our lives; we worry we won't make an impact. In the late hours or early mornings, we wonder what we'll be remembered for, what our legacy will be. While some people are trying to make it through another week, others find themselves succeeding in the wrong things—and despairing as a result.

Make no mistake. All of us, at some point, wonder if what we're doing matters. But for some of us, maybe for you, this question sticks. It haunts you. And the answer taunts you. It whispers from afar. Keeps you wondering and waiting. All the while, deep inside your heart, something dangerous stirs. Something you're afraid to admit.

Something I was afraid to admit.

Years ago, I was in Spain. As part of a college study abroad program, I was spending the fall semester of my junior year in Seville—a beautiful, historic city full of art and wonder.

On a very ordinary day, my friend Martha and I took a trip to *La Giralda*, the impressive tower adorning the world's third-largest cathedral and the place where Columbus was allegedly entombed. After ascending the massive spiral staircase, we gazed out over the city. We looked down, watching thousands of souls pass by.

As we descended the stairs and entered the cathedral Martha posed a thought I'll never forget: "I wonder what kind of legacy I'll leave."

It hung in the air for all to hear.

We stopped and stood in front of the altar. There we were, surrounded by centuries of art, and Martha wanted to know which of her creations would endure. What would still be standing in another thousand years? And I had to wonder the same.

We are all hoping something we do in this world matters. We want our creations to stay with people forever. As Steve Jobs, the founder of Apple Computers, once said, we all long to "put a dent in the universe."

It's true; we'd all like to leave some kind of impact on this ball of dirt. But most of us, tragically, won't. We're afraid of the cost. We're worried we don't have what it takes. We're anxious about the road it takes to get good enough. We're terrified we'll fail to live up to our idea of greatness. So we play it safe and abide by the rules.

Before we even start, we sabotage our work and subvert our genius.

And how, pray tell, do we do this? With words. Subtle but serious words that kill our passion before we can pursue it. Words like "aspiring" and "wannabe." Words like "I wish" and "someday."

There is a solution to this. A simple way of facing your fears and living the dream: Become who you are.

YOU ALREADY KNOW
WHO YOU ARE

"All is not lost, all is not lost.
Become who you are
It happens once in a lifetime."
— *SWITCHFOOT*

Trust me when I say that while it's simple, it's not easy. I know. I've been there.

At a time in my life not so long ago, I was wrestling with this longing too. I wanted my life to matter. And I whined about it a lot. One day, a friend asked me what my dream was, and I told him I didn't have one. Which was exactly the wrong thing to say.

"That's too bad," he said, baiting me. "Because I would've said it was to be a writer. I guess I was wrong," he shrugged and turned away.

I began to steam. Swallowing hard and working up the courage to speak, I finally uttered, "Well, I guess it is. I mean—I suppose I hope to maybe be a writer... *someday.*"

My friend looked at me without blinking and said, "Jeff, you don't have to *want* to be a writer. You *are* a

writer. You just need to write."

Those words struck a chord in me. The next day, I started writing. Without excuse or exception (and without being very good), I began.

And you know what? My friend was right. Pretty soon, I became a writer—almost without realizing it. It began with a few hundred words before sunrise, every day. Sure, those words stayed on my hard drive at first. But with practice and discipline, I got better. I was publishing articles and producing work on a regular basis that frankly surprised me.

I found my dream not by searching for it, but by submitting to what I had always hoped was true: I was, in fact, a writer. All I had to do was write.

Anyone can do this. All it requires is a simple, scary solution: Believe you already *are* what you want to be. *And then start acting like it.*

WHY LISTEN TO ME?

I'm nobody special. Just a writer who got frustrated with a broken system and decided to do something about it.

This idea isn't new. In fact, I'm in the trenches with lots of writers who are building platforms that earn them the chance to deliver a message. I've learned from many of them. I've taught a few more of them. Each one focuses on a unique passion, and people are paying attention.

That's really all I'm talking about here—nothing you couldn't Google on your own if you had all the time and patience on your hands to search out their stories.

ANYONE CAN DO THIS. ALL IT REQUIRES IS A SIMPLE, SCARY SOLUTION: BELIEVE YOU ALREADY ARE WHAT YOU WANT TO BE. AND THEN START ACTING LIKE IT.

There *is*, however, something that qualifies me to share this with you, something unique that I am quite familiar with: the frustrations of a writer. I've been living it for a while now. The long nights. The thankless work. The bad pay. Even the windfall projects followed by dry spells and feelings of doubt and despair. I know them all quite well.

But here's the rub: It doesn't have to be this way. There is a way out of this "feast or famine" cycle in which most writers find themselves. A way to break the chains of fame and accolades, to spurn the addiction of an audience and create lasting work. A way for the gatekeepers to come to *you.* You can create the life every writer dreams of: never having to write a proposal or query letter again. Never having to pitch; never having to compromise. Wouldn't that be great?

I'm here to tell you it's possible. I'm also here to tell you it takes hard work and smart work and patience. I've made plenty of mistakes, but I've also had some very talented people teach me some invaluable lessons. They've given me solid advice that's served me well.

I've learned the secret to writing for the love of it and getting acknowledged for your work.

And I'm going to share it with you.

A NOTE ABOUT THIS EDITION

When this book first came out, I was still slogging out this writing thing in the early mornings and late nights, fitting it around my day job. It took another year of writing and hustling and building my brand to be able to support my family.

Much of the content in this edition is the same, but I've made some changes to help you apply it. I've updated the stories to reflect lessons I've learned since the first edition was published. I've restructured it to more intentionally guide you through both the craft and the business aspects of the writing life. I've tried to organize it so you can use the parts that are meaningful to you right where you are now.

If you want to write and put your words in the corner of your hard drive and you're happy with that, then great. The first section is for you. Write. Clarify your worldview. Get comfortable with your voice. Build a habit of writing that works for you.

But if you want your words to get the attention they deserve as a product of your passion, then at some point, you'll need to look at how to expand your reach. That's when you'll be ready for the second part.

And honestly, you'll grow faster as a writer when you get feedback on your work from editors and readers. It all works together.

So let's get started.

PART 1: WRITING

ONE:
CLAIMING THE TITLE

———◆———

Every day, somewhere, a writer is born.

She comes into the world with a destiny: to share her words and proclaim a message. To make a difference. These words have the power to move and motivate strangers, to shake the earth and rattle the heavens. If only she would write them.

It's a choice, writing is. One that belongs to you and me. We get to choose it (or not) every single day. So whether the world hears your message—whether you leave the impact you were born to make—is entirely up to you.

Scary, isn't it?

There are, of course, thousands who won't make this choice. They'll fail to be who they are and live up to their calling. We will forever miss their words. And this is tragic.

But you? You were born for this. And you are ready to make a different choice. You are ready to be a writer,

even if you don't feel it yet.

FALLING BACK IN LOVE WITH WRITING

The first time I fell in love, I was twenty years old. At least, I *thought* I was in love.

The relationship was all wrong from day one. We broke up and got back together exactly four and a half times—the half being when we started going out again but didn't tell our friends (because we had already broken up four times). After the last cycle of breakups and make-ups, we stayed together for a year and a half.

Not so long into that year and a half though, the relationship started to grow stale. It became comfortable. And then it became boring. The feelings faded, and all that was left was a commitment neither of us wanted to be in. The problem was we didn't know how to end it. We felt stuck.

As the relationship fizzled, I grew distant, and she stopped showing affection. We found clever and convenient ways to avoid each other. Still, for some reason, we stayed together. We just couldn't end it—it was an awful, confusing cycle.

I BROKE UP WITH MY OLD BLOG AND STARTED OVER. AND WHEN I DID, I STARTED ACTUALLY WRITING.

I felt the way a lot of people in broken relationships feel. I felt trapped. We were hanging on to something longer than we should have. But we were scared

and didn't know how to let go of what had become safe and predictable.

Then, one day, the relationship ended. It happened by accident, as all the best breakups do. We started talking about the past few months, and before we knew it, we were saying goodbye. Afterwards, I remember going to the park, lying on a picnic table, and breathing a deep sigh of relief. I finally felt free.

Years later, I was reminded of this experience when I looked at my approach to writing.

The pursuit of blogging—and the career, success, and fame I thought would follow—had poisoned my relationship with writing. The promise of getting published and pulling in the big bucks distracted me from my true purpose: doing the real work. The work of writing. I was finding clever and convenient ways to avoid writing. I updated my website. I created business plans and pitch letters. I talked about writing. I stalled. But it was just that first relationship all over again. It took the tough love of a friend to remind me I had a dream.

After that conversation, my friend's words reverberated in my mind: *You are a writer. You just need to write.* So that's what I did. I stopped wasting time *thinking* about writing or *talking* about writing. I broke up with my old blog and started over. And when I did, I started actually writing. Which is the hardest thing in the world for a writer to do.

But once I got over the initial pain, I started to feel that same relief. I felt free.

I would wake up at five every morning and write for hours before going to work. When I finished the day, I'd spend another couple hours in the evening. Just

writing. I would write on lunch breaks and whenever I could grab a spare moment. I'd stay up late and put in weekend hours. Every chance I could get, I was writing.

I didn't care about anything else. I was euphoric. I was in love.

Maybe you've experienced this. Maybe you hope to. Either way, I want to make something clear.

You *are* a writer. You just need to write.

> IT'S TIME TO KILL THE EXCUSES AND START WRITING. TIME TO BECOME A WRITER AGAIN. NOT A MARKETER OR AN ENTREPRENEUR. NOT A BLOGGER OR BUSINESSPERSON. A WRITER. A REAL ONE.

TURNING PRO

All of this—this process of becoming a writer—starts not with the hands, and not even with the heart, but with the head.

When I started writing, I had all sorts of anxiety. Who was I, pretending to be a writer? How could I possibly call myself one when I hadn't even written a real book, when I hadn't been published or paid for my work?

As I began to pursue my craft, I learned something important. (In fact, I'm still learning it, and if the pros I'm learning from are any indication, I'll keep learning it for the rest of my life.) Embracing your identity as a writer is mostly

a mind game. It's about tricking yourself into becoming who you are. If you do this long enough, you begin to believe it. And pretty soon, you start acting like it too.

Sounds a little crazy, right? Maybe. But I learned it from a true pro.

When I started writing, titles intimidated me, and I wondered what it would take to "arrive," to be considered legitimate. I secretly worried I would never feel like a writer, despite what I told myself.

So I asked an expert.

In *The War of Art*, Steven Pressfield explains you have to "turn pro" in your head before you can do it on paper. More important than book deals and hitting the *New York Times* Best Seller list is this belief in yourself. In other words, he contends you have to trick yourself, because you *aren't* a writer *yet*. You're just beginning. But we all have to start somewhere, and a writing career begins with *you*.

At first, I didn't buy this. It sounded a little like snake oil to me. So I emailed Mr. Pressfield. I wanted to know the truth about this writing business, what it really took. And he granted me an interview. So, I asked him, "When do you *really* become a writer? Is it when you get an agent? When you sign your first book contract? When you sell 100,000 copies?"

He said it was none of that. The truth was much simpler. When do you become a writer? "When you say you are," he said.

I didn't get it. I poked and prodded, trying to dig deeper. I wanted practical steps and formulas. Where were my charts and diagrams? But he insisted, "Screw what everyone else says. You are when you say you are."

At the end of our conversation, he had blown past all my objections. I had no arguments left, so I decided to

give it a shot. What choice did I have? All this self-doubt, all this questioning—I was willing to do whatever it took to alleviate the lack of confidence I felt.

So I started saying I was a writer. I put it on my Facebook page. Included it in email signatures. Everywhere I could, I wrote the word "writer" beside my name. It was kind of ridiculous, but something crazy happened as a result of this campaign.

It actually *worked*.

As I started making these public proclamations of identity, I started believing them. I began to trust my calling before I had anything to show for it. Before anyone else called me one, I started believing I was a writer. I started acting like one.

Then something strange happened. I started to get better at my craft. All because of a few mere words (and the action that flowed from believing them).

Through this process, I learned a crucial lesson:

> *BEFORE OTHERS WILL BELIEVE WHAT IS TRUE ABOUT YOU, YOU'LL HAVE TO BELIEVE IT YOURSELF.*

LET'S DO THIS

Okay, we're going to do an exercise together now.

This isn't positive thinking mumbo jumbo; it's affirming something deep inside of you that you've been resisting. Do it as an act of faith, of believing before you see. It's time to submit, to surrender.

Are you ready? Write it now before this sense of urgency leaves you.

Grab a pen and paper. Not your phone or iPad or computer. Make this a tactile experience. Ready?

Now write the following words:

I am a writer.

Good. Now do it tomorrow and the next day. Continue this practice for the rest of your life until you believe it. And then keep doing it as a means of practice and ritual. Because there will always be doubt. Always anxiety and second-guessing. Just keep doing it.

Welcome to the life of an artist.

I AM A WRITER.
I AM A WRITER.
I AM A WRITER.
I AM A WRITER.
I AM A WRITER.
I AM A WRITER.
I AM A WRITER.
I AM A WRITER.
I AM A WRITER.
I AM A WRITER.
I AM A WRITER.
I AM A WRITER.
I AM A WRITER.

TWO:

WRITERS WRITE

———◆———

There's a trend amongst writers. Most have more ideas than they know what to do with. They have hundreds of half-written articles and a few books started.

How many of these projects have they finished? None.

I was the same way. Once a month, on a Saturday, when the wind was blowing just right and I felt inspired, I would write. I'd write for hours at a time—long, drawn-out essays about who-knows-what. It felt beautiful and precious, but really it was a waste of energy.

I would come up with long lists of imaginative ideas

> *THIS IS DANGEROUS TERRITORY,*
> *WHEN YOUR CREATIVITY HIJACKS*
> *YOUR PRODUCTIVITY.*

and potential projects—websites and communities and other brilliant creations. Some of them I'd actually

start. I even followed through with a few for more than a week. But I finished exactly none.

I wasn't doing. I wasn't creating. I was only dreaming. This is dangerous territory, when your creativity hijacks your productivity. Do you know what's really at work here, when we thrash around with countless projects, never finishing any of them?

FEAR.

Fear of finishing. Fear of picking one thing and finishing it. We think, *What if it's the wrong thing? What if I mess it up?* Your fear will lead you to false answers. Fear will tell you the world will end. You'll be embarrassed. You'll waste time. You'll never get another chance. But all those things are lies. What really happens is you learn. You grow.

So here's the truth:

THERE IS NO WRONG THING. JUST BEGIN.

Cancel all backup plans, pick a project, and move forward. It doesn't matter what you pick. Maybe it's a book, an article, or whatever. Write it. And finish it. Because once you learn how to finish, you'll be able to start again. You'll start another great project and finish it. And another. And another.

Start writing. If you don't, all you're doing is waiting.

PRACTICE MAKES HABITS

A few years back, I finished my first half-marathon. But it wasn't my first attempt at running one. The year before, I tried to run a race and failed. I didn't practice, didn't buy the right shoes, and didn't do the work. My "training" consisted of sitting around day after day and then choosing a random day to throw my shoes on and try to run five miles. Halfway through training, I injured myself and had to quit.

So I tried again. But this time, I took it seriously. I gave the sport the respect it deserved. I realized if I put the time and effort in, I could do it. I committed to a plan and made room in my life to practice. I used the right equipment and invested a little money, which made me take it even more seriously.

Several months later, I crossed the finish line.

Not too long after the race, I woke up early one morning, drank some coffee, and went for a five-mile run. After that, I wrote a few pages for my book and went to work.

That evening, I looked back on the day and was shocked by all I had accomplished. Getting up early, running five miles, writing over a thousand words—how did this *happen*?

It happened subtly, as all things well-practiced do. It didn't happen by thinking about it or talking about it. Not through wasting time with meaningless goals or silly, fruitless plans. No, it happened from doing the work—creating habits and building momentum.

Professional weight lifters don't get sore like you and I do when we lift weights. They show up, push themselves, build muscle, and go home. Then

tomorrow, they get up and do it again. The less they think, the more successful they are.

The same is true of any craft. Soreness is the result of untrained muscle. If you practice every day, you don't get fatigued. All muscles are built this way, even creative ones. If you do anything long enough, it becomes habitual.

And really, isn't the goal for any passion in life to wake up and do it without thinking? Without having to debate or fight or convince yourself it's the right thing to do? This can happen for writing, running, and anything else you want to do in life. It won't be easy, and it might occasionally hurt, but if you do something long enough, you eventually stop thinking about it. It can become effortless.

Just like running or weightlifting or anything else, daily practice builds habits. When you start writing every day, you'll find your groove. You'll find yourself with a bank of ideas to write about. You'll get more comfortable with your voice. So will others. As those things come together, you'll discover your message.

This may take months or years. But if you keep showing up, keep practicing and doing the work of a professional, you'll find it.

DE-CLUTTER

So you might be feeling a little anxious right now. One of the biggest objections I hear to the idea of writing every day is: "I don't have time."

Life is busy. You have a job. You have kids. You have obligations. I get it. I have a lot of those too. But here's

the thing: You have to choose your priorities, or they will choose you.

In our world today, distractions abound. Thousands of advertising messages inundate us every single day. As a result, we live hurried, frantic lives full of interruptions. The average person's attention span is short—less than three minutes—and it's getting shorter. Go ahead and try to watch a five-minute video on YouTube. I dare you. If you get through it without checking email, changing browser tabs, or picking up your phone (or wanting to), I applaud you. You have a rare ability that most now struggle to match.

For me, the worst of all these distractions is social media. Facebook. Twitter. Friendfeed. Blogger. Ning. Plaxo. LinkedIn. Google Plus. Goodreads. Snapchat. WordPress. Instagram. AIM. Jabber. Tumblr. Flickr. Foursquare. Myspace. Digg. Delicious. StumbleUpon. Yelp. Path. Vine. Pinterest. And *more*.

THERE IS THIS EXPECTATION… "YOU HAVE TO BE EVERYWHERE." THAT'S RIDICULOUS.

I've been on them all. And I have little to show for it. Online, there is this expectation (usually self-imposed) for writers and communicators. It's a fallacy, but it doesn't stop well-meaning people from saying it all the time. The myth goes like this: "You have to be everywhere."

That's ridiculous. You know who says that? People who are always responding to the latest trend. I know this, because I was one of them.

But when I started writing every day, I realized a painful truth: I can't react and create at the same time.

Neither can you. Our brains don't work well when we try doing too many things. Though we may have eclectic interests, we can only do one thing at a time and do it well.

Multitasking is a myth. *You can either create or react.* But you can't do both. Choose wisely.

It's hard to say no, but it's even harder to spin your wheels. It's worse to waste your creative energy on frivolous things like an endless series of check-ins. I don't play the game anymore. I pick a few networks that work for me, I limit the time I'm there, and I say "good riddance" to the rest. And in doing this, I recover the time to write. To create. If you're going to be a real writer, you'll have to make similar sacrifices.

To create your best work, you'll have to make room for it. You'll have to cut out the excess noise and focus on what really matters: the writing.

I don't know your distraction, but you do. Maybe it's not social media. Maybe it's TV. Or the latest online game. Whatever it is, fess up to it, do a little purging, and get to work.

THE SECRET TO SUCCESSFUL WRITING

After "I don't have time," the biggest challenge many writers face is the blank page.

Experts say you're supposed to imagine a specific person. This is a trick marketers use to find their ideal customer. They choose someone, give that one person a name and a face, and focus all communication efforts on reaching that person.

But when you're still grabbing that piece of paper and writing "I am a writer"—when you're still trying to build that habit, but you're not really sure what to write about—it's easy to get hung up here. I know I did. So I put a twist on it.

> *I CHOSE TO WRITE FOR ONE—AND ONLY ONE—PERSON: MYSELF.*

This is true when you're starting out, and it's true when you've been writing for years. The only person you need to worry about writing for is you. This is the secret to satisfaction in anything: doing what gives you life and not trying to live up to others' expectations.

As you do this consistently over time, you may find what I did: You're not as unique as you thought. There are a lot more people like you than you realize.

When I published my online manifesto and over a thousand people downloaded it in a week, I realized I wasn't the only one who felt that way. It made me feel not so alone. Incidentally, that's the same thing people thought when they read it.

Someone put it like this: "If you're 'one in a million,' and the world is full of seven billion people, that means there are seven thousand people just like you." When you think about it like that, you don't feel so alone anymore, do you? Which raises the question: If there are thousands of people out there waiting to hear from you, how do you find them?

Is it hard to believe it starts with you?

Most people don't know what they want. We writers sometimes forget this. So we write the words we think

others want to hear. There's just one problem with this: It's not how you create art.

As a communicator, your voice matters. More than you realize. We (your audience) are relying on you for your insight and profundity. We need you to poke and prod, not merely pander.

You have to be yourself, to speak in a way that is true to you. This is the next step to claiming your life as a writer—taking yourself seriously so your audience will too.

I admit this was hard for me. I had spent years helping other people find their voices. I wasn't sure I'd recognize my own voice when it came. And truth is, I didn't. I needed people to tell me when I hit my sweet spot. When I struck a nerve. I needed help. I needed feedback.

When I started writing every day without excuse, I didn't know if my material was resonating with anyone. I was just showing up. It took a few friends telling me I'd found my voice before I realized it.

> *WE (YOUR AUDIENCE) ARE RELYING ON YOU FOR YOUR INSIGHT AND PROFUNDITY. WE NEED YOU TO POKE AND PROD, NOT MERELY PANDER.*

The same may be true for you. Some days, it's enough of a chore just to put your butt in a chair and stay put. To create something. Anything. If you do this long enough, though, you start to create really good work. And the people who care about you will tell you it's good.

It may be subtle at first, but if you continue—if you

persevere—you'll discover a reality all professionals know quite well. Everything is practice. Every word you write and action you take is a chance to get better. And as you get better, as you connect with your voice and you start hearing you're not alone, the blank page becomes less intimidating and more exciting.

MULTITASKING IS A MYTH.

THREE:

THE MYTH OF GOOD

I used to think I was a great writer. Stubborn and pig-headed, I didn't want to change. I didn't want to grow. But I really wasn't that good.

And it's sad, but I find many promising writers are the same way. When I ask people to rewrite a guest post or make suggestions on how to improve their writing, they get defensive. Or more often the case, I never hear from them again. It is a rare occasion to hear from a writer who asks for feedback and means it.

There are good writers, and there are bad writers.

Good writers practice. They take time to write, crafting and editing a piece until it's just right. They spend hours and days just revising.

Good writers take criticism on the chin and say "thank you" to helpful feedback; they listen to both the external and internal voices that drive them. And they use it all to make their writing better. They're resigned to the fact that first drafts suck and that the true mark

GOOD WRITERS TAKE CRITICISM ON THE CHIN AND SAY "THANK YOU." THEY LISTEN TO BOTH THE EXTERNAL AND INTERNAL VOICES THAT DRIVE THEM. AND THEY USE IT ALL TO MAKE THEIR WRITING BETTER. of a champion is a commitment to the craft. It's not about writing in spurts of inspiration. It's about doing the work, day-in and day-out.

Good writers push through because they believe in what they're doing. They understand this is more than a profession or hobby. It's a calling, a vocation.

Bad writers don't understand this, which is precisely what makes them bad writers. They presume their writing has achieved a certain level of excellence, so they are closed off to the concept of editing or rewriting.

They can seem haughty, prideful, and arrogant. But really, it's laziness and fear (mostly fear). Why don't they edit? Why don't they write pieces before they're due and take time to review them? Why do they give into the myth of the overnight genius? Because they're afraid of putting the work in—and failing.

As a result, their work is scattered and disconnected, not nearly as good as they think.

But even in a world of good writers and bad writers, there's no such thing as good writing or bad writing.

DEFINING GOOD

People often email me excerpts of their work, anxiously asking, "Is this good?" And I can honestly answer *I don't know*. I have no idea, and I honestly don't care to know.

I know what I like, but that doesn't matter. What matters is what works—what's effective.

"Good" is subjective. What makes art good? Or music good? Opinions vary, depending on the person. But have you ever heard a couple of construction workers, saying:

"Harry, I disagree with you. That hammer is not good. I see why you would appreciate it, but my tastes differ."

"Well, Lloyd, I see what you mean, but we'll have to agree to disagree on this point. I find the aesthetic beauty of this fine piece to be far superior to any of its contemporaries."

Of course not. That would be ridiculous. How do you judge a good hammer? By how effective it is. Sure, even in carpentry, opinions of quality differ, but what really matters is what gets the job done.

The same is true for writing.

Effective writing is hard to argue with. It gets the job done. Sure, there are some fundamentals. Effective writing follows the basic rules of grammar and composition (except when it doesn't). Effective writing gets to the point and doesn't ramble. Aim for that.

But beyond that, really, stop trying to be good.

People's definitions of "good" vary. What one

EFFECTIVE WRITING IS HARD TO ARGUE WITH. IT GETS THE JOB DONE.

person loves, another hates. So stop obsessing over being a good writer. It doesn't matter. Too many writers are caught up with insecure thoughts of whether they are any good. It's crazy. Enough with this neurotic behavior. Time to be confident in your craft.

The trick now is to write in a way that finds an audience. Do you know the secret? It has to do with confidence. Look at all the crazy authors out there. Do you really think there isn't an audience for your content? Trust me; they are out there. You just need to find them.

STARTING FREE

One of my favorite essays on writing is "Shitty First Drafts" by Anne Lamott.

Lamott's thesis is this: All first drafts suck, so get it over already. (Really. That's about her style. A little crass at times, but it gets the point across.)

Her point is that you need to dismiss the myth that says you can write something amazing on your first attempt. Or that you should even try. That's what amateurs believe.

Here's a dirty little secret:

> *THE PROFESSIONAL SHOWS UP EVERY DAY, READY TO DO THE WORK. NO MAGIC BEANS OR MYSTICAL FORMULAS. JUST SIMPLE, HARD WORK.*

Great communicators drive home their point in the most concise, challenging way possible. And they get rid of anything that interferes with their message.

The way they do it is to write a terrible first draft first.

Let's face it: The "genius" stuff happens in the editing process. Most successful writers go through a tedious process of drafting and shaping their content to get something worth sharing. How do they do this? They write every day. They write a thousand terrible words to find a hundred words worth using. They share their work with a close friend. They edit, tweak, and then ship. But they have to have something to start the process with. And so do you.

Commit to writing something—anything—today. Maybe it's just a sentence or a title. But get it on paper (or screen). Write it just to get it out. Right. Now. You might have a nugget of something that was inspired at 3 a.m. But write free. Keep your fingers moving.

It might feel like a waste, but it works: Write more, so you can edit more. Starting with raw thoughts then slicing down your fluff to the core essentials is how you get to genius.

GOOD WRITING IS IN THE EDITING

> *"I meant what I said, and I said what I meant."*
>
> — *DR. SEUSS*

This kinda takes all the mystery out of how to write something that could be sheer genius, huh?

Yup. That's the point.

Look, most writers want to be geniuses. I'll be honest. I'd like to be a genius too. There's no question about that. We want to be remembered for our wisdom and wit. But very few of us believe that something as dull as a drawn-out, disciplined process is what will get us there.

Here's the thing, though: Genius is very simple. Simple, but not easy.

Do we remark at the pithy sayings of Confucius, Ralph Waldo Emerson, and Jesus because they're long and exhaustive? Or because they're short and profound?

History proves that those remembered for their words are not always the most verbose. Think of every famous movie line, political speech, and quote you've ever heard. Why did they stick with you? Was it because of the length of the content? Usually not. Rather, it's often because of the punch of their words.

Writing is about space. It's about what's *not* said. About showing rather than telling. About making every word count.

So how do you do this? First, you practice a lot. Edit often. (I'm full of helpful tricks, aren't I?)

OK. Enough with the obvious. Believe it or not, you don't need as many words as you think. As the saying goes, good writing is rewriting. If you can say it in fewer words (without sacrificing clarity), do it. Sometimes, we skirt around the issues. We small-talk, chit-chat, or do any number of other hyphenated activities. When you write, don't play around. Get to the point already. Figure out what you want to say, and say it. Then be done.

And don't think because you write memoir or

short stories, you're somehow exempt. You're not. If you're filling the pages with unnecessary words, you are wasting the reader's time.

Remember: Every. Word. Counts. Act like it.

If you're a wordy person, this can be hard. Really hard. So once you've finished your piece, try cutting it in half. Make it a game to get your word count down to the very minimum. This is counter-intuitive for most, but trust me; your reader (and editor, if you have one) will thank you for it.

Until you've sliced and diced, your piece isn't ready. Not until you've crossed out every word but the ones you absolutely need. The best way to do this is to get another pair of eyes on your work. Until you've trained yourself to notice words you would normally ignore, you'll need help.

Here are a few things to look for:

• Do a document search for all uses of "that" and "very"—kill as many of them as possible. These words are rarely needed.

• Reread the piece. Cut as many adverbs as possible. These are words that typically end in -ly (like "typically"). This is especially important when writing dialogue, *he said intently.*

• Look for complex sentences using lots of "ands" and "buts"—try simplifying some of them. Reread them and see if the meaning is more clear.

• Destroy weak phrases like "I think" or "in my opinion" that corrupt your argument. Say what needs to be said, or don't say it at all. When you do use such a phrase, make it count.

By the way, the point of all this is not to be terse for

the sake of being terse. The point is to learn to make every word matter.

PRACTICE IN PUBLIC

Real writers practice. I'm not talking about rehearsal. I'm talking about doing what musicians and athletes and lion tamers all do to get ready for their work. To become awesome at their craft.

They practice in public. They show up, every day, without excuse or complaint (okay, maybe some complaint). They perform. They go to work. They stop stalling and playing around and actually get stuff done.

Writing is no different.

Look, it's easy to dump words on a page and tuck it away in a drawer. But to be a real writer, you have to take some risks. You have to put your work out there. Throw it against the wall, and see if it sticks.

To be a real writer, you have to take some risks. You have to put your work out there. Throw it against the wall, and see if it sticks.

Writing is active. It requires your fully conscious self. You need to show up and show us your gift. Until you do that, you're just practicing in private. Playing around. Kidding yourself. Don't do that.

It's time to put your work out there—not because you'll succeed. Quite the opposite, in fact. You'll probably fail (I'm such an encourager). But it's important. Because

in the failure, you can learn.

You'll have to learn the lesson every writer hates learning. You'll have to live through the fear so you can hear the hard feedback that will help you grow.

Steve Jobs once said, "Real artists ship." I love that. However, someone recently reminded me it's the *shipping* part that's emphasized when it should be the artist part. In other words, just because it's shipped doesn't make it art. But if it doesn't ship, it doesn't matter *what* it is.

Real artists risk failure every time they release their work into the world. If your words are going to matter, you will have to do the same. You will have to let go. Until you do, you're not creating art. You're just screwing around.

Remember: The fear of something is always scarier than the thing itself. Yes, there is pain and rejection. But the greatest failure is to never risk at all.

Okay, this is it. No more dress rehearsals or dialogue. No more coffee dates to commiserate with your peers. Enough talking; start doing.

Time to get to work. Show us what you got.

FOUR:

IT GETS TOUGH

———————◆———————

Remember a few chapters ago when I told you how my relationship with writing turned stale? How it was time for me to break up with my blog?

For five years, I wrote a blog nobody read. I measured my traffic and did everything I could to maximize my reach. All the while, my heart slowly died, and I grew bitter.

I watched other writers succeed in ways I hadn't, and I envied them. Eventually, I grew to resent them. Why? Because I wasn't doing what I wanted. I was writing, but I wasn't enjoying the process. I was only chasing results. So what did I do? I went back to the basics: writing for the love of it. Not profit or prestige. Not analytics or metrics. Just writing for the sake of *writing*.

As a result, something amazing happened: I started to have fun. And the quality of my work soared. I finally felt free to do what I loved.

You can do this too. But this kind of change comes with a cost. As with all good things, there will be sacrifice—a price to pay.

WHEN YOU FEEL TRAPPED

It will happen, eventually. You will do something you love, and after a while, you'll forget why you started. Whether it's a relationship, a career, or a calling, you start to feel trapped.

This happens to the best of us. Sometimes it's just silence. We work and work, but it feels like we're shouting into a vacuum. We lose steam and want to break up with our passions.

But sometimes success does it too. We blow up, and it doesn't matter. Why? Because the reason we started no longer motivates us. We check out and want to move on. We dream of quitting.

When this happens, you're in a tough place. You start resenting what brought you so much attention in the first place. You may even find yourself longing to reinvent your work.

What you do next though is what forms your character. It's what determines the course of your life's work and what makes a legacy. It's the difference between someone who creates something memorable and meaningful and someone who just gives up.

It's tempting. At these times, you'll want to give up. Throw in the towel. Move to another country, buy a cabin in the mountains, and forget about the world.

But this is not the end. It's only the beginning of another journey. Whether you're starting to tackle

writing for the first time or you're a lifelong veteran, relax. There is better work you've yet to create.

So how do we do this? How do we get out of the trap?

We start with courage.

WHAT IT REALLY TAKES

> *"This business of...being a writer is ultimately about asking yourself, 'How alive am I willing to be?'"*
>
> — *ANNE LAMOTT*

Writing is hard—really hard. It's work. Somehow, they never talk about this in your college composition class. Nobody wants to tell you the truth, because if you knew how hard it was, you'd never start in the first place. You'd quit before you began.

So, let's begin there—with the truth—shall we?

This isn't easy, this writing life. It is, however, a noble calling. And like most things worth fighting for, it will require all of you. Not just your fingers and brain, but your whole self. You have to bare your soul on the page, then turn around and ask the world to look at it.

I can't lie to you.

It's harder than you think.

It's not enough to be good. You have to be great.

Nobody cares about you. People care about themselves.

It's more about *who* you know than *what* you know.

It will take a lot to do this day after day. You will struggle. You will face fear, and fear will wear a different mask every day. But you have to keep going. And this is harder than it sounds. To make it, you must be courageous.

None of this matters one hill of beans if you aren't brave. If you do not persevere. No guide or set of tools can prepare you for the rejection you will face, the criticism you will endure, or the pain you will experience. Because you will. You will get rejected. If you're writing something that matters, people will disagree with you. They may even attack you and call you names.

Nobody ever tells you this. They don't tell you how writing takes more hours and energy than you'll ever be able to plan for. That no one cares about you as a writer until you've actually written something. That what you write isn't as important as getting your work in front of the right people. That, above all, if you don't love it, you're kind of screwed.

At least, nobody ever told me those things. Maybe they did, and I just wasn't listening.

This might sound harsh, but it's the truth. You'd better be writing because you can't *not* write. You'd better love it. (Otherwise, quit now.)

But if you do love it, I mean *really* love it, the world needs you far more than you know. We are waiting for your words. Longing to be changed. We need your art —whether you realize it or not.

Will you share it? Will you believe you are a writer and start writing? Will you keep writing when it gets tough?

I hope so.

So now what do you do—now that you've been acquainted with the real world? Now that you've summoned up all the courage you have?

What does it really take to make it as a writer? Well, there are two camps.

THE FIRST CAMP: SUFFER

> *"There is nothing to writing. All you do is sit down at a typewriter and bleed."*
>
> — *ERNEST HEMINGWAY*

Writing is hell. This is one camp of thinking.

The reasoning goes like this: *This is serious work, so if you want to do it right, it will have to cost you everything. Including your life. No two ways about it.*

We read about writers like Hemingway the drunk or Dickinson the recluse, and we romanticize their lives. We think, *This is just the way it goes.* And we set ourselves up for lives of dysfunction.

It's a cheery thought, isn't it? This idea that all it takes to succeed as a writer is the ability to deal with a considerable amount of blood loss? *Thanks a lot, Ernie.* No wonder so many creatives are given to suicide and substance abuse.

There are plenty of writers who buy into this fallacy. Writers who choose the Hemingway route and suffer through their life's work. They subject themselves to the violence of their art instead of conquering it. They ruin marriages and type masterpieces while completely

wasted. They wallow.

If you're a wimp like me, though, you may not be too keen on suffering. In which case, you can relax. There is another way. I have a friend who says this about writing: "Don't be the sacrifice; *make* it." I like that.

You don't have to suffer; you can *work* instead.

THE SECOND CAMP: WORK

> *"Talent alone cannot make a writer. There must be a man behind the book."*
>
> — *RALPH WALDO EMERSON*

Talent is not enough to succeed. We know this. We see it every day.

Hollywood is not just full of the world's best actors, but those who also made the right connections and paid their dues. Music Row has welcomed not only the world's most remarkable musicians, but also those who knew the right people.

Of course, we don't want to be the talentless reality show stars who soak up their 15 minutes of fame and then fade away. Talent and skill are important. But they are also a given.

If you are going to succeed as a writer, you are going to have to learn to be smart. To have thick skin. To be more than talented. You are going to have to be a marketer, an entrepreneur, and a talented salesperson.

Because this is a *business*.

When people tell me they want to publish a book but aren't willing to build a platform or worry about marketing, I don't believe them. If you want to be a writer—if you want this bad enough—you will work. Why *wouldn't* you be willing to give this everything you have? If this is your dream we're talking about, why would you hold anything back?

If your art is going to have the impact you want, you had better learn the tricks of the trade—not so you can become part of the system, but so you can start changing lives.

I wish someone would've told me this ten years ago. I would've gotten to work a lot sooner. And I would've succeeded sooner, too.

I wish I'd have known there were simple tools to help writers do what they were made to do: write, not deal with ridiculous bureaucracies.

I wish I'd have known how to network and make meaningful connections. And that it was all easier and less sleazy than I thought.

I wish I'd have gotten online and started blogging much sooner.

If I had done all those things when I was in college, I'd have authored dozens of books by now. I'm sure of it.

But I didn't do those things. Instead I waited for permission. To be picked.

Maybe you're waiting too. If you are, consider this your official wake-up call: *It's time to stop waiting to be asked and start creating.*

THE MOST IMPORTANT LESSON A WRITER MUST LEARN

For years, I've been writing and publishing articles —both online and offline. I've experienced the pain of being ignored and the disappointment of being rejected.

But in a matter of months, it all went away.

I've been writing my whole life, but in just a few months, I learned the most important lesson about building a writing career (which means it doesn't take long—doesn't have to, anyway).

I've learned secrets and tricks to publishing that used to baffle and frustrate me. And I'm going to tell you how I did it: how I focused on the craft and wrote for the love of it. How I got published without having to plead and grovel. How the gatekeepers started coming to me.

I'm no longer pounding on publishers' doors, pleading to be picked. Instead, *I've learned to pick myself.*

Without trying to sound like an infomercial, you can pick yourself too. And it will make all the difference.

There's a foolish way to pursue a writing career (waiting to be picked) and a smart way (building a platform worth noticing). Do yourself a favor and choose the latter. Create a brand that resonates. Make meaningful connections that help you succeed.

I'VE LEARNED TO PICK MYSELF.

Are you ready to get started with this? To live the life every writer dreams of? To stop pitching and start writing?

It begins with people.

BUILD A COMMUNITY

When I first started writing and sharing my work, it was on a blog. Blogs let you see how many readers you're affecting every day, so it was easy for me to get off-track—to focus on results instead of process.

I chased numbers not people. I thought like a pollster not a conversationalist. Not surprisingly, I failed. I had hundreds of daily visitors but no friends or followers. No one who really cared about my work.

But when I stopped focusing on all that and came back to my passion, a crazy thing happened. People started caring.

I found that when you stop seeking public approval, something interesting happens: People will be deeply attracted to your work. They won't be able to help it.

Passion is contagious. If you treat people like human beings and write from a place that is deep and true, you will find your audience.

But you won't do it alone.

You will need others' help. You will need a community. And community begins with one person who truly believes in the work.

That person is you.

Now comes the hard part. The part where you apply this (or don't). Where you find your tribe and build your path to publishing.

So what do you say? Time to start writing?

Thought so.

PEOPLE WILL
BE DEEPLY
ATTRACTED TO
YOUR WORK.
THEY WON'T
BE ABLE TO
HELP IT.

PART 2: GETTING READ

FIVE:

THREE TOOLS EVERY WRITER NEEDS

---◆---

Every writer wants her message to be heard. It's a universal human need to be noticed, embraced, and accepted. We all want to belong. We want to share our art with an audience and see our ideas spread.

There's just one problem: There's too much noise in this world. We are overwhelmed with endless ads and opportunities. At least I am. It causes me to wonder:

- What should I spend my time on?
- What's actually worth noticing?
- Are any messages worth listening to anymore?

This is the world we live in today: a noisy, cluttered place in which the loudest voices get the most attention. And they are usually the ones least worthy of that attention.

The unfortunate reality is we are probably missing

your work. Not because it's not good, but because we've learned to tune it out. It takes more than talent or luck to be a writer. You'll be waiting a long time if you are hoping to be discovered without lifting a finger to earn the attention of readers.

No, you have to be intentional. Every successful communicator has three important tools, in some form or another:

1. A platform to share your writing.

2. A brand to build trust with readers.

3. Channels of connection to distribute your art.

Without these tools, your reach will be limited. Your art will only go so far.

Let's start with the first.

SIX:

YOU NEED A PLATFORM

———◆———

Every Sunday for the past 150 years (give or take), Londoners have assembled at Speakers' Corner in Hyde Park to share their thoughts on religion, politics, and pretty much anything else they could think of. To stand out above the crowd, speakers often used to stand on wooden crates—soapboxes.

They had a platform. A stage. A place from which to communicate a message. Without this, they were just another voice in a crowd. Now, the Internet is our Hyde Park. And the first tool you need is the right platform to stand on.

You might be rolling your eyes at the mention of platform. Everyone seems to be talking about it: authors, artists, and entrepreneurs alike. And it can seem pretty slimy. Self-promotional. Narcissistic. Some people dismiss it as ego-driven aspiration spawned by an obsession with celebrity. And certainly, there's some of that going on in our culture. But that's not what I

NOW, THE INTERNET IS OUR HYDE PARK. AND THE FIRST TOOL YOU NEED IS THE RIGHT PLATFORM TO STAND ON. mean when I talk about platform.

Whatever you want to do in the world, you need influence. You need authority. You need permission. Even parents and schoolteachers and construction foremen need authority to lead—if they want people to follow. But as a writer, you need to establish that authority for yourself. You need to earn your readers' permission to give them more of your words.

Your platform is your home base. It's the place where new people can meet you. It's the place where you earn their trust and permission. It's where your loyal readers know they can find you week after week.

Understanding this is essential to spreading your message and earning the attention of new readers. Either you build it or you just keep shouting into the crowd.

And trust me, you don't want to shout.

Here's an example. Every day, a newspaper appears at the end of my driveway. I didn't ask for it. I don't read it. It sits there and gets rained on and run over. It gets wet and flat and rots there until I haul the can out on Sunday night. I pick it up (along with its six buddies), toss it into the bin, and send it off to the landfill.

That's shouting. I'm sure the reporters, editors, pressmen, and delivery people put a lot of work into that newspaper every day. But I don't care. I didn't ask

for it. I don't want to read it. It doesn't matter to me.

They are shouting, and I'm not listening.

Here's the thing: If you have something worth saying, you want people to listen because it matters to them.

Your platform is something only *you* can build. You can't borrow or steal it. You can't force people to care. You can only earn it. It's the permission people give you to communicate with them.

The question is: Will you build it?

Will you create your own rules? Or will you continue to be bound to someone else's standards? To blend in with the rest of the crowd?

Not sure where to start? Not feeling ready?

That's OK. I wasn't either.

READY OR NOT, HERE YOU COME

When I first started my writing blog, goinswriter. com, I felt like a fool. I had never published a book and had only gotten a few articles in print over the years. I did a lot of online writing and blogging, but that was it.

Who the heck was I to offer advice?

Then I started hearing about other bloggers who were considered experts in their fields. I found out many of them didn't start out as experts either. Instead, they just started asking questions. They started poking and probing and finding the answers to their burning questions. They shared the questions they were asking and the answers they found. They took their readers along on their journey of discovery.

I realized something: There's no such thing as "ready." If you're struggling, if you're not feeling "good enough" or "ready," just stop it. That's not the issue. Not really.

The issue is fear. Namely, fear of starting. The fear of what it takes to keep going, to finish, to follow through. The fear of looking like you don't have it all sorted out yet. The fear of being vulnerable.

But guess what? Your readers don't have it all figured out either. And they will connect a lot more with someone they can relate to. Someone who is honest. Someone who is interested in taking them along on the wild ride. That someone is you.

Are you willing to push through the fear of rejection and embarrassment? To be curious and ask questions? To persevere and commit to learning? To work harder than most so *you* can become the expert?

If so, you're ready to begin. You're ready to build a platform.

Remember: A platform is people. It doesn't get much simpler than that. Be yourself, and you'll find that others—the people just like you—will join you.

EXAMPLES OF PLATFORMS

So what does a platform look like?

Honestly, there is no single way to do this. There are many different ways to get your message out there; the question is how to choose which one is right for you? Here are a few types to consider:

- YouTube channel

- Podcast

YOUR PLATFORM IS YOUR HOME BASE.

- Blog
- Newspaper column
- TV show
- Speaking career

Oprah has a platform. So does Bono. As does J.K. Rowling. What's special about them isn't where they share their message (although having your own channel on TV is certainly special), it's what they have to say. Each one of them has a unique worldview and a community of people who share that perspective. People who listen to them.

If you want people to pay attention to what you have to say, you have to be legitimate. You need to have a reason for people to listen. You have to know who you are.

I've found five main types of platforms. Before you start building yours, you should decide which is best for you.

THE JOURNALIST

The Journalist builds his platform on asking questions. The only requisite for this type of platform is curiosity.

This is the example I just shared with you. The blogger who began his journey by asking questions and sharing the answers on his blog.

But it's not just true for bloggers. It could be a chef who started out barely able to boil water. Whatever you're interested in, if you are a naturally inquisitive person, this may be an excellent platform for you to build.

THE PROPHET

The Prophet builds her platform on telling the truth. The requisite for this type of platform is a passion for authenticity. I can think of few people who have done this better than my friend Jamie Wright.

Jamie authors a popular blog called The Very Worst Missionary, on which she riffs and rants about faith, life, and other stuff that bugs her. She complains and cusses and often confesses. In short, Jamie says all the things missionaries wish they could say. And people love her for it. Ask any of her readers why and they'd probably tell you, "Because she's real." She tells the truth—the dirty, ugly, beautiful truth.

Another great example is Seth Godin. Seth is an iconoclast in the business world. He calls out the brokenness of the status quo—whether it's in marketing, education, or charity work—and challenges us to something better.

Prophets are not always popular. They are unpredictable and are usually offending someone. This is what good prophets do. They not only condemn the dark, but also call us into the light. And by taking a stand, they build a loyal community of people who share their perspective.

If you are the person who can't *not* speak the truth, you might just build a community as a Prophet.

THE ARTIST

The Artist builds his platform by creating art—whether it be music, painting, food, or poetry. The

requirement is an eye for beauty.

One of my favorite artists is Jon Foreman, the lead singer of the band Switchfoot. Jon communicates the truth of his message through the words he sings and the notes he plays. He challenges his listeners through powerful art that causes them to ask questions long after the song is over.

Artists speak to our hearts, not our minds. They show us—through their art—that another world is possible.

Having sold millions of records, toured the world many times, and appeared on *The Tonight Show*, it's hard to say it hasn't worked for Jon and his band.

If you can't help but see beauty in the ordinary, and you are passionate to share it with the people around you, you're probably an Artist.

THE PROFESSOR

The Professor builds her platform on facts and information. She does extensive research until she has achieved mastery. Of course, there is always more to learn, but this type of person knows more than most. The only requirements are a longing to learn and an ability to explain.

A great example of someone who has built a platform this way is Jim Collins. Jim is a well-respected and sought-after speaker and author. He has written *Good to Great, Built to Last,* and *How the Mighty Fall*—all bestselling business books based on extensive research and case studies he and his team have done. These books are not light reading. They are full of charts and

information and case studies.

The Professor loves data. If you are going to build your expertise this way, you had better love reading, studying, and analyzing (or find a team that does).

But if you're great at teaching and you're an expert at something, then maybe you should be The Professor.

THE CELEBRITY

Perhaps the oddest type of platform to build (and the most visible) is that of The Celebrity.

These people are famous because, well, they're famous. Products of a media-saturated culture, celebrities are a new breed of influencers. They woo and scandalize, and we love them nonetheless. Often, the person is good-looking or talented at a particular craft (e.g., acting), but not always.

A celebrity earns his audience through charisma. But not everyone can be a celebrity.

The best example of this type of platform is Ashton Kutcher. A talented entrepreneur and well-known actor, Ashton has something that makes him especially interesting to his fans and customers. He is charismatic and full of energy, ideas, and excitement. As a result, people love listening to him.

Networkers would fall into this group as well. They have influence, because they're good with people. They may not be the up-front-and-center person, but they are charismatic too.

If you're great at getting to know people, at drawing people close, connecting people and building

community, then you could build a Celebrity-type platform.

WHAT TYPE FITS YOU?

These are the five main types of platforms I've observed. I'm sure there are others, but these seem to cover a lot of opportunities and possibilities for you. If you have a message you want to get out to the world, you need to identify what type of voice you have and, therefore, what type of platform you will build.

So let's recap:

• If you are a naturally inquisitive person, a Journalist platform may be an excellent one for you to build.

• If you are the person who can't *not* speak the truth, you might just build a community as a Prophet.

• If you can't help but see beauty in the ordinary, and you are passionate to share it with the people around you, you're probably an Artist.

• If you're great at teaching and you're an expert at something, then maybe you should be The Professor.

• If you're great at getting to know people, at drawing people close, at connecting people and building community, then you could build a Celebrity-type platform.

In the end, it doesn't matter which type of platform you choose. You could even combine elements of a couple. (But not more than a couple, please!)

Just find your natural you. Your readers will love you and trust you for it.

IF YOU HAVE SOMETHING WORTH SAYING, YOU WANT PEOPLE TO LISTEN BECAUSE IT MATTERS TO THEM.

HOW TO BUILD A PLATFORM

Once you know who you are, you have to find the people who need you.

In the old days, a lot of this was left to chance. Musicians had to play a lot of dives before they ever stepped onto a main stage. Screenwriters moved to Hollywood and paid their dues for years before one of their stories ever made it to the theater.

But now, things have changed. Now, you don't have to wait. The odds are still against you, and this will be hard. But the good news is this isn't left to chance. You don't have to wait anymore. Now, you can create your own luck.

When it comes to platform, there are so many options—so many opportunities—it can feel overwhelming. So let's simplify it, shall we?

There are three important steps to building any platform:

1. Get experience.
2. Demonstrate competence.
3. Generate buzz.

Let me unpack that. There are three parts to building any successful platform—three steps or actions you need to take to get noticed.

First, you need experience. This is about apprenticeship. About paying your dues. It's about spending time getting good at your craft.

Second, you need to demonstrate competence. This means showing us what you have. It means practicing in public. For musicians, this means playing live shows. For writers, it means blogging—write, share,

listen, repeat. For artists, it means putting your work on display for the world to see. You need to show the world you have what it takes and to find someone who will give you a chance.

Third, you need to generate buzz. This is the part that can feel a little weird. But you have to get people talking about you. If you have experience and are good at what you do, but no one advocates for you, you don't matter.

You see, it's perfectly fine to write just for the love of it, but if you want to touch someone's life (as most writers do), it's just not enough. You need buzz. And getting buzz—getting people to talk about you—means more than just having some fans. It includes finding patrons and supporters and people who will spread your message *for* you. It's a tribe.

That's all well and good, you may be thinking. *But I don't even know where to start.* You have a point. This may all sound overwhelming. It may sound vague. It may be too ethereal.

So what do you *do?* How do you get noticed in a world full of noise, distractions, and advertisements? What's the best way to build a platform and earn influence?

Easy. *Help people.*

Be a resource to others. Do favors. Be selfless. In a world of me-first and gimme-gimme, this is totally crazy. And unexpected. Which is why it works.

Generosity catches people off-guard; they don't see it coming. This is why they trust you, why they take time to listen to you. You have their best interest in mind.

Helping people builds trust. With trust comes

permission. With permission, the opportunity to share your work.

SEVEN:

YOUR BRAND IS YOU

———————◆———————

I used to write for a magazine. Every time I sent in a new piece (after publishing multiple articles with them), I had to re-introduce myself. Every. Single. Time. It was pathetic. And terribly frustrating. But I had no home base—no website, no landing zone, no platform. I was forgettable, and I got what I was asking for.

To gain momentum, to build a community of friends and fans and patrons, you have to have an image and personality people recognize. And it needs to be distinctly yours. Otherwise, you disappear. You don't exist. You're camouflaged, blending in with the background of other voices.

You need a brand.

For years, I neglected this. I partnered with writers and organizations that had strong brands. I thought somehow their influence would transfer to me. I was wrong. It doesn't work like that. Only you can own your own platform. Only you can manage your own brand.

Trust me, I learned this one the hard way.

One of the biggest mistakes writers make—one of the biggest ones I made—is believing they don't need a brand. *Wrong.* This is a common fallacy and, quite frankly, ridiculous. Everyone has a brand. One way or another, you are making an impression on your audience. A brand will happen whether you like it or not. Either you intentionally *choose* one for yourself, or one will be given to you.

The good news is you have a choice. With the Internet and the million ways people are connecting with each other every day, you can take command of your personal brand. In fact, you *must.* It's not a perfect process, but you can guide it. You can influence what people think of you, if you care enough to act.

Now, you can't get away with manipulation. You can't misuse marketing gimmicks to trick your audience into believing something that isn't true. If you do, you will be found out, exposed, and discovered for the fraud you are. So don't waste your time trying.

But if you do this branding thing right, your audience will thank you, because you will help them know who you are and what to expect. Think of it as a promise—one you get to deliver on with every word you write and every article you publish. Every book you sign. Every email you respond to. Every fan you meet.

Maybe it sounds squishy, this idea that branding is about "the promise of you." So what, exactly, *is* a brand?

That's not a bad question. It *is* a little squishy. In fact, there's a lot of confusion about what the word even means. It means different things to different people. For some, a brand is a logo. For others, it's

your reputation or the trust people put in a product. The word itself may conjure images of Apple or Coca-Cola.

The idea of branding may cause you to wince or make you roll your eyes. If that's the case, trust me, I understand. But what I mean when I say "brand" is actually quite simple.

A brand is who you are. But it's more than that. It's your truest self. The part people remember.

MAKING YOURSELF MEMORABLE

So how do you capture that? How do you build a brand? How do you put all of these elements together and create a reputation people can trust?

You make yourself unforgettable. As Seth Godin says, be remarkable in the most literal way—so people will remark about you. The point in all of this is not to turn into a marketing machine, but to get people to *not forget you.* It's about making yourself memorable. About standing out in all the noise. This won't just happen. You will have to work.

YOUR BRAND IS THE MANIFESTATION OF YOUR IDENTITY. IT'S WHAT MAKES YOU, YOU.

If you'll allow me to be abstract for a minute, your brand is the manifestation of your identity. It's what makes you, you. But it's not just your personality. It's who you consciously choose to be. It's an intentional identity you don for the sake of your art.

Don't misunderstand me. I don't mean your brand can be whatever you want or that it's every little bit of you hung out for the world to see. It's simply an important part of yourself revealed to an audience. Not in a disingenuous way, but in a way that is helpful, consistent, and understandable to your readers.

For example, I like guacamole, but it doesn't need to be part of my brand. A brand is *part* of you, but it can't be the whole person—with all your nuances and idiosyncrasies. That's impossible.

Your brand is the sum of all the parts of you that are important to your writing. If you've chosen to be The Professor, your brand will emphasize your experience in your field. It might also reflect your passion for research or analysis. And it might also touch on your family or your faith if those inform your teaching.

But if you're an Artist or Celebrity type, your brand will highlight your personality. It will instantly connect your audience with your idea of beauty or of a good time. But it probably won't stress that Harvard MBA you worked so hard for.

The point isn't to cram as much in as possible. Instead, choose the parts of your personality you want your brand to emphasize (and know why you chose them). My affinity for avocados doesn't need to be central in my brand. What does is my belief that passion is central to life.

There are three elements to every brand. When building yours, pay attention to these:

• *Name:* Your actual name, a brand name, or a pseudonym.

• *Image:* A logo, your face, or some kind of custom headshot.

YOUR BRAND IS THE SUM OF ALL THE PARTS OF YOU THAT ARE IMPORTANT TO YOUR WRITING.

- *Voice:* Your style and tone of communication. It's how people recognize you.

So let's unpack these so you can build a brand from scratch in three simple (but not easy) steps.

CHOOSE A NAME

A good brand name can be as simple as your first and last name. In many cases, this is the best choice you can make.

For others, a more creative route will be appropriate. Maybe your name is hard to spell, or maybe someone else has already registered the domain and social media handles. Or maybe you're a budding graffiti artist and you'd simply like to avoid getting arrested.

In that case, you might choose to go with a pseudonym, like Mark Twain or George Eliot. For bloggers, a brand name can also be a sort of "call sign" like Problogger or Tall Skinny Kiwi. It can even be something iconic like Madonna or Avi or Banksy.

Whatever you do, make your name memorable. Make it work for you. Make it consistent with the rest of your brand.

And as you choose a name, take some time to carefully weigh the pros and cons of your options. Your brand needs to serve the purpose of your writing. Don't stick with something that doesn't work. Also, don't rush into the first idea that comes to mind. Once you have a published name, it will be hard (and confusing) to change it. Don't take this lightly, but don't overthink it and get stuck here either.

This is important; treat it as such.

DESIGN YOUR LOOK

Designing your look takes intentionality. Your look may be an icon or logotype. It may be a certain color scheme or a photo of you. It may even be a creative combination of all three. It could even be a symbol like Prince had (or whatever name he goes by these days—talk about brand confusion!).

Designing your look is a great example of how a brand is a representation of you but not your whole self.

For instance, you don't want your headshots to be of you right after you get out of bed. At the same time,

YOUR BRAND NEEDS TO SERVE THE PURPOSE OF YOUR WRITING.

you don't want an image that looks nothing like you. Your image needs to represent you. The whole point is for people to recognize you.

And even if you're not an artist, this is something you want to have a say in, not something you completely delegate or defer.

When designing your look, remember these tips:

- Be recognizable, inviting, and interesting.

- Use a professional photographer or designer to help you. Outsource what you can't do yourself, but make sure you speak into the process.

- Be certain people will notice you and your work by your logo, headshots, etc.

- Get feedback from friends, fans, and followers throughout the branding process.

FINDING YOUR VOICE

Finding your voice is one of the hardest, most important tasks a writer will undertake. Some authors say it takes years. Others say it's a matter of writing hundreds of thousands of words. The one non-negotiable is this: You will have to work to find your voice. It will not come to you in a daydream or revelation. It's not just how you talk or act. It's a product of elbow grease.

A writer's voice is the combination of passion, personality, and people. It's communication in a way that is both personally fulfilling and relevant to your audience. It's meaningful and marketable.

If your writing only moves you—and no one else—then you haven't found your voice.

Here are a few questions to ask yourself:

• Describe yourself in a few adjectives. What do you and others come up with?

• Take note of your interests: favorite books, movies, music, etc. What do they have in common?

• Imagine your ideal reader. Describe him or her. Write a letter to this person (including a name).

As you take note of your unique style of writing and the ideal reader you're trying to reach, you will begin to find your voice. Don't worry, though; it takes time. Give yourself lots of grace and room to fail.

You'll need it.

BRANDING MYSELF

I learned most of this by trial and error, and I hope my advice can help you establish your brand quicker than I did. Stumbling upon my own personal brand was less intentional than it should have been. I kind of backed into it, accidentally. Call me a nerd, but it happened through my blog.

The *.com* domain for my full name was already taken, so I did a variation of it with goinswriter.com, since I knew I wanted to build a platform around my writing. I repurposed a headshot from a family photo shoot I did with my wife. I put it on every piece of collateral I had: website, Twitter, Facebook, etc.

Then I started reaching out to people, building relationships, and writing.

The more I wrote, the more comfortable I became with my voice. As I looked around, I saw how my writing resonated with others. Before I realized it, I had a brand, a unique writing style that attracted others. And I had no idea.

In fact, a friend had to tell me, "Jeff, you've found your voice," before I would believe it.

Maybe you'll need the same reminder. That's why we can't simply practice in a corner somewhere in a darkly lit room. You've got to get out in the world and share your work. Otherwise, you'll always doubt yourself.

Your brand is waiting. You just need to find it.

EIGHT:
CHANNELS OF
CONNECTION

Remember how I had to repeatedly reintroduce myself to the same magazine? How I had to keep pitching that magazine like it was the first time? Talk about the definition of insanity.

I heard from them again, but this time it was a different conversation.

Years ago, I stopped submitting pitches to this publication. I was frustrated and fed up and frankly, just plain tired. So I dumped them. I focused on building a meaningful platform, which allowed me to share my work with a broader audience.

I had forgotten about the magazine—and most gatekeepers, for that matter. And then something strange happened. Much like the pretty girl who's not interested in you, it makes you want her even more. (I didn't set up the analogy right, because in this case I

am the pretty girl. But you get my point.)

Anyway, eventually, the magazine emailed me asking for a contribution. They wanted to republish something I had already written—on my blog. Imagine that.

Don't overlook how monumental of a shift this was. For years, I had pitched this magazine, and they'd occasionally publish me (maybe one out of ten pitches). Every time, I had to fight to get noticed as if it were the first time. Then, after building a platform, they came to me, asking *me* for permission to publish.

I had now become the gatekeeper.

This is the magic of the age in which we now live. We are all publishers. And the people we previously pitched to? Now, we're peers.

Since starting my current blog and building an audience, I've been approached by more publishers than I had in the past six years combined. I've been offered book deals and speaking gigs and other writing opportunities. I've been able to shift from writing in the margins of my life to supporting my family by writing. The members of my online course have built an opportunity center in Kenya.

All because of a blog. Because I chose myself instead of waiting for others to do it.

Here's the truth: Most writers don't like promoting themselves. I sure don't. But what alternative do we have? If you want to matter, you have to get your content in front of people; you have to be connected to others: agents, editors, publishers, readers, and writers.

We've chosen a craft requiring solitude and focus, and this "people-stuff" can be hard. It's easy to skip

on past it. Which is precisely why most writers make this tragic mistake. They neglect the importance of building meaningful connections.

And they pay dearly for it.

A platform and a brand are nothing without channels to connect people to your content. This is the third tool every writer needs: a channel—or better yet, channels—to share your work and allow readers to interact with you.

Another word for this is marketing. But it's much deeper. It's relationships.

THE NEW ASSEMBLY LINE

Everywhere you look, people are assembling. They're lining up for community. Gathering around unique interests and passions. The term "niche" has never been more popular. And instead of casting wide nets and going for big numbers, online entrepreneurs are finding success by narrowing their focus.

They're using technology to find where people are and to join the conversation there.

If you're going to find an audience for your writing, you're going to have to jump into this new world. You're going to have to join some existing channels and networks—if you want your message to matter.

Here are a few examples:

- Facebook
- Twitter
- Email
- Phone

- Conferences
- Meetups

When two people relate to each other—when they exchange useful information and a meaningful experience is shared—a connection is made. Therein lies the rub. A connection must be meaningful. It must be mutual. It must matter.

Meaningful: The listener must care about what you're sharing. You must have permission and attention.

Mutual: Both parties need to be in it. One may benefit more than the other, but it cannot be completely one-sided.

Matter: Not only must both sides care about the content, but there needs to be fruit. Something good must result from the connection.

This is the hard part of trying to get noticed for communicating a message. It's the part most writers neglect. They get scared or lazy. They procrastinate and delay the inevitable. Or they get excited about sharing their art and rush the process. They get pushy and burn bridges.

Either way, they wonder why nobody pays attention to what they have to say, why they're virtually anonymous.

This concept of building long-term relationships slowly may not be easy for you. But it's necessary. Even if it takes discipline, don't skip this part. This aspect of networking is essential to making your work matter.

Once you've started to build a platform and establish a strong brand, you need to start creating inroads. Connections. Relationships.

You'll want to earn followers and friends and subscribers, but you'll need more than daily guests and visitors.

You need to build credibility with your audience so they give you permission to communicate with them whenever you like. This is a significant mark of trust. Without it, you have nothing but a series of one-hit wonders.

How do you earn this permission? You ask.

HOW TO ASK PERMISSION

> *"Treating people with respect is the best way to earn their attention."*
>
> *— SETH GODIN*

Think about what happens when you enter a retail store. Within seconds, a salesperson approaches you. "Can I help you?" he asks.

What do you say? Usually, "No, thanks. I'm just looking."

But that's not true, is it? You walked into the store to buy something, and you just chased away the person who could help you. Why? Because we don't trust salespeople.

Likewise, when you're first starting out, your audience doesn't trust you. Not yet. Why should they? There's no relationship, no trust built. They don't know you from a can of Spam.

This might sound harsh, but nobody cares about you.

Not yet. If you want them to, you have to realize something: You don't get to decide what matters. *They* do.

So who are "they"? Your future fans. And how do you earn their trust? You need to do something for them to show you're worthy of letting down their guard.

When he decided to give away free copies of an eBook, Michael Hyatt saw his email list grow from 3,000 subscribers to over 30,000 in a matter of months. He saw a 1,000% trust increase with his audience in less than a year—all because he decided to be helpful.

In other words, generosity works. Hyatt earned the trust of his audience and permission to contact them again.

Without your audience's trust, without permission, you're only adding to the noise. The best way to combat this is to be over-the-top helpful, to be unexpectedly generous. And while you're being generous and earning trust, you can also build permission to reach out and serve your audience in the future.

Here are some ways to ask and build permission, so you can deliver a message:

• Invite Facebook fans or Twitter followers to read an epic blog post.

• Invite blog readers to subscribe to your newsletter.

• Ask another writer or potential mentor to coffee.

• Give away something for free—like an eBook—in exchange for attention.

The possibilities are endless, but not all of them are equal. And of course, you need to do more than ask. You need to be smart. You need to serve your way into relationships. The most important question you

YOU NEED TO SERVE YOUR WAY INTO RELATIONSHIPS. THE MOST IMPORTANT QUESTION YOU SHOULD ASK IS, "WHAT'S IN IT FOR THEM?"

should ask is, "What's in it for them?" As long as they are getting more than they're giving—as long as there's value for them—the relationship will keep growing.

So once you get up the courage to consistently meet people, connecting and serving them right where they are, what's the best way to start earning permission and building a fan base? What is the best way to make meaningful connections? What do you need to make all this stick?

A channel of your very own.

For years, I overlooked the importance of having my own channel. I thought guest-posting and having followers on Facebook and Twitter were enough. I thought my own channel was just a nice add-on. It's not. It's a necessity.

A channel of your own is essential to building a platform and extending your reach beyond your immediate networks. Without it, you are either borrowing attention or stealing it. The only way to earn it is by sharing a meaningful message through a channel you own.

A CHANNEL OF YOUR OWN IS ESSENTIAL TO BUILDING A PLATFORM AND EXTENDING YOUR REACH BEYOND YOUR IMMEDIATE NETWORKS.

For me, this is the email list that connects people to my blog. For Dan Miller, it's his podcast. For Gretchen Rubin, it's her extensive network of relationships.

What will your channel be?

WHAT YOU GET
(WHEN YOU REACH OUT)

If you decide to build a platform, to create a brand, and to connect with others, you will see things start to happen. I hope I'm not making this sound easy because it's not. But it's possible, which is something that's never been true before.

You, the writer, can now create a destiny for yourself. Amazing, right?

Here are some of the potential opportunities awaiting you:

- Book deals (without the proposal)
- Offers to write for magazines (without a query letter)
- Money (I have to throw that in there)
- Free stuff (like books and products)
- Interview opportunities
- Chances to connect with other writers and influential people

It's simple, but it's not easy. And it's definitely worth the work.

Nowadays, I'm not afraid of publishing. I don't fear rejection. I've picked myself, and others have seen the difference. Instead of pleading to be published, the gatekeepers are coming to me. Honestly, it's pretty cool.

I'm no John Grisham, but I'm pretty content with where I am. Every day, my writing is read by thousands of people—something I never would have dreamed of when I first picked up a pen and paper and started writing about gargoyles. (I was in sixth grade; give me a break.)

This didn't take years of living in obscurity. Once I figured it out, it took about eight months. I did it with a full-time job and a wife, working in the evenings and early mornings. It wasn't easy, but it wasn't impossible either. I put the time in and showed up—and I saw results.

There's no perfect formula, but being intentional is important. You can follow a similar process, or you can try something completely different and find what works for you. Maybe you'll see success sooner; maybe it will take longer.

But I promise one thing: If you do the work, you'll see the results. The age in which we live is full of incredible opportunities for writers and communicators.

IT'S THE AGE OF NO EXCUSE—WHERE ANYTHING IS POSSIBLE AND THE ONLY ONE HOLDING YOU BACK IS YOU.

For me, all of this began with a pledge, with a simple understanding: *I am a writer. I just need to write.*

Now, your opportunity is here. Don't let it pass you by. And remember: It all begins with a change of mind.

You are a writer...

PART 3: TAKING ACTION

NINE:
GETTING STARTED

To this point, we've been talking a lot about ideas and strategies. But now, it's time to get practical. To sharpen our pencils and get started.

And this is where I'm supposed to say, "Getting started is easy!" But I can't do that to you. It's not easy at all. Getting started is the hardest part. As you begin, you'll find every excuse to wait and every reason to delay. You'll stop to reflect on what to write about. You'll come up with reasons why it's not time yet, why you're not ready. And you will be lying to yourself.

You're ready. Ready enough, anyway. You don't have to have it all figured out yet. You just need to begin. You'll figure out the rest as you go. Trust me.

So, where do you begin? It depends on the kind of work you want to do, but your beginning might look something like this:

- Start a blog, and start sharing your work. Make a schedule. Practice in public.

- Sign up for an account on Twitter, and start some conversations.

- Create a Facebook page for your blog, books, etc.

- Build an email newsletter list (sign up for one on Aweber.com or Mailchimp.com) and reward people for subscribing.

- Continue creating great work worth talking about. Show up day after day, making promises and delivering on them consistently over time.

Wherever you choose to start, start small and build. Always asking permission, always showing respect. This process, mixed with a little patience and faith, will always yield results. They may not be what you expect, but something *will* happen.

LAUNCHING A BLOG

Okay, let's get technical. There are so many opportunities to blog out there—where do you begin? What's good? What's bad?

In the olden days (which is a couple years ago in Internet time), a blog was the "in" thing to have. And it still is. But blogs have outgrown the old idea of an online diary. Today, a blog is really a full-scale website, where you can provide updated content, shopping carts to sell stuff, and pages for special information like resources, your portfolio, and even videos or podcast recordings.

Personally, I love WordPress. In my opinion, having a self-hosted website (which means you own it all; you just pay for space on a company's web server) is essential for a writer. However, if getting started is

freaking you out and you're terrified of technology, you may want to begin with baby steps, like an account on wordpress.com. If you go this route, you'll still have a few decisions to make, but you can be blogging in just a couple of minutes.

BLOGS HAVE OUTGROWN THE OLD IDEA OF AN ONLINE DIARY. TODAY, A BLOG IS REALLY A FULL-SCALE WEBSITE.

The choices? Well, you can create a truly zero-cost website, or you can elect to upgrade for $15-20 a year. The free website would have a domain name like "goinswriter.wordpress.com" while the paid upgrade would get you your own domain name like "goinswriter. com." (See how the cumbersome "wordpress" was dropped?)

Having a free account on some blogging service is nice for updating your grandma (who is, apparently, pretty tech savvy), but it's not enough for a professional. If you've got a presence on a platform you don't own, you're leaving yourself vulnerable to the whims of a stranger who doesn't have your best interest in mind. You're also pretty limited in what you can do to grow your platform and your permission-based email list.

Launching a self-hosted blog can be a little technical to set up (you will need web hosting), but once you begin, you will have total freedom over how you communicate and connect with others. If you're not scared of technology, you can set up your self-hosted blog in under eight minutes. I show you how on my blog.

If you are a little less tech-focused and you need help doing this, there are great full-service providers like the guys at OutstandingSetup.com. Plus, with

websites like Problogger.net and others, there are all kinds of helpful resources to get you started.

Whatever you do, don't let technology stop you from getting started.

THREE IMPORTANT RELATIONSHIPS

Once you begin, you will want to start building connections. Without other people, it will be hard to succeed. So where do you begin?

You could hop on Twitter or Facebook and start shouting, "Check out my new blog!" But I'm betting by now, you know what I'd think if you did that. So... don't do that.

Let's think a little more strategically, shall we? Ultimately, there are three must-have relationships that will extend your reach, and each of them is absolutely necessary:

• *Fans:* You need to build meaningful connections with your tribe of followers.

• *Friends:* You need to connect with others who are doing what you are.

• *Patrons:* You need to earn influence with influencers who will support your work.

A *fan* is someone who admires and follows your work. These people will spread your message and pay money for your work. Hopefully every time you offer something new.

A *friend* is a peer—someone who can relate to the work you do. You should have an inner circle of friends to hold you accountable to being true to your craft and

art. These people will help you get better.

A *patron* is an advocate—someone who supports you financially or through lending you his or her influence.

These people will mentor you and help you go to the next level. They will increase your influence and help you grow in wisdom.

And once you understand who you're reaching out to, you should:

- *Create amazing stuff.* Find out what people need and deliver it to them.

- *Be generous.* Reward your readers by giving them freebies once in a while. Do favors. Serve them.

- *Ask permission.* Never assume. Always invite.

HOW TO WIN FANS

The best way to win a fan is to create meaningful art—work that will move people and change the world. But when you're just getting started, you're working pretty blindly. How do you know what people want?

You don't.

Once you build a platform, you can ask your audience. Until then, you have to go with intuition. The good news is that online distribution and communication are virtually free. So you can try stuff out without costing you a ton of time or money.

Begin, and tweak as you go.

If you're not sure what to do, try writing something dangerous—something that challenges the status quo or contradicts a social convention. Create something

CREATE AMAZING STUFF. FIND OUT WHAT PEOPLE NEED AND DELIVER IT TO THEM.

worth disagreeing with. Chances are you'll find someone who likes it.

Rinse and repeat.

HOW TO MAKE A FRIEND

Friends are important to your work. Without peers and cheerleaders, we're doomed to live lives of solitude and limited impact. And writers are generally known to be an introverted bunch. So sometimes, it's hard to make friends, hard to meet new people.

Still, this is essential. If you need help, here are three ways to build a relationship:

• *Reach out.* Email people. Reply to them on Twitter. Start a conversation.

• *Help.* Begin the relationship by serving and showing interest in the other person.

• *Follow up.* Don't let the relationship lie fallow. Stay in touch.

It's really that simple. The best way to make a friend is to show interest in someone else without an agenda.

THE BEST WAY TO WIN A FAN IS TO CREATE MEANINGFUL ART—WORK THAT WILL MOVE PEOPLE AND CHANGE THE WORLD.

I hope you're seeing a pattern here: Serving people is the best way to earn influence. The most influential people I know do this regularly. They give more than they take; they ask more than they tell.

If you want your writing to reach the most people possible, you'll need friends to help you grow, champion your work, and encourage you in the process.

And like your mom probably told you, the best way to find a friend is to be one yourself.

HOW TO EARN A PATRON

Neither finding fans nor making friends is a revolutionary concept. We've been doing both since we were in kindergarten, with varying levels of success. But earning patrons? That one is probably new to you. At least it was to me. So let's camp out here for a bit.

We live in an incredible age. Technology is amazing and accessible. Ease of communication allows you to reach millions in seconds—all at the touch of your fingertips. Yet, ironically, writers and artists are more alone than they've ever been.

SERVING PEOPLE IS THE BEST WAY TO EARN INFLUENCE.

One challenge in this age of super-connectedness is the prevalence of competition, especially amongst creatives. But it shouldn't be that way. We need help. We need someone to show us the ropes. We need influencers who are generous with their platforms to help us find our audiences.

Without the Medici family, Michelangelo would never have painted the Sistine Chapel. Without his friends at Atari, Steve Jobs never would've started Apple.

Without patrons, you won't reach your potential.

We all need people who believe in the work we do and help support us. But patrons are different. How? For one, they already have influence and expertise. They've answered questions that we haven't even begun to imagine asking. They have platforms, and they've earned their audiences' trust.

They are also extremely busy. It may be hard to get time with these important people, but it's well worth the effort. So how do you get potential patrons to notice you?

WE ALL NEED PEOPLE WHO BELIEVE IN THE WORK WE DO AND HELP SUPPORT US.

- *Ask.* Start with an email or a letter. Ask for a short meeting. This can be in person, over Skype, or whatever is most convenient for them.

- *Interview.* Show interest. Come prepared with questions. Respect their time.

- *Stay in touch.* Follow up with an email (or phone call) after the meeting (you'd be surprised how many people don't do this).

- *Repeat.* The real secret is diligence and perseverance. Do this enough times with enough people, and you'll find someone who believes in you.

This is scary. Trust me, I know.

When I first started seeking out patrons, I was hesitant to start networking with other people who could help me. It felt sleazy. I didn't like the idea of promoting myself.

Instead, I did what I knew: I offered to interview people I wanted to connect with. I would reach out on Twitter, Facebook, or via email, and ask someone to

coffee. Then, I'd interview them. Afterwards, I would publish the article and let the person know. This was my excuse to follow up. With many of the relationships, I just continued to stay in touch.

Over time, this gave me the confidence to reach out to other people. This simple formula has allowed me to get people like Seth Godin and Michael Hyatt to endorse my work. It's allowed me to publish exclusive interviews with writers like Steven Pressfield and many, many others.

> *YOU CAN FIND PATRONS TOO, IF YOU TAKE THE TIME TO ASK. YOU MUST BE BOLD AND RISK A LITTLE, BUT I PROMISE YOU: THE OUTCOME IS WORTH THE RISK.*

The best way to set yourself up for success with a patron is to demonstrate competency and proactively reach out. Before you ask for a meeting, show them what you've done or are capable of doing. Then, when setting up the meeting, the trick is to make it easy for *them.* Offer to buy them coffee or breakfast near their workplace. Do it when it's convenient for them, not you.

When you meet, make it more about them than you. However, don't be surprised if they have their own questions. Come prepared to both ask and answer. Take notes. Show them you value their time and input.

Obviously, you want them to help you, to endorse the work you do. But don't ask in the first meeting. Instead,

make it your primary goal to build a relationship. If they like you, you'll have plenty of opportunities to ask later.

After the meeting, thank them and send a list of notes to show you actually remembered their advice. You want them to know you took their time seriously. Then, like any relationship, let it build over time. Follow up. Find opportunities to share information and to serve them.

Relationships are important. They can lead to all kinds of opportunities and breakthroughs in your career.

If you're intimidated or afraid of reaching out to potential patrons, know that it gets easier. You just need to start. If you're already doing this, keep going. It never hurts to have more people on your side. Every success is a story of community—a complex network of people helping each other. Don't forget: You can't do this alone.

TEN:

BEFORE YOUR
FIRST BOOK

———◆———

Announce yourself at a party as a writer, and see what happens. Chances are, more than one person will respond, "I'd like to write a book someday."

Every writer wants to get published. It's the dream we long for, the recognition we crave (even when we say we don't). But when you get started, it doesn't take long to realize getting published isn't easy. It takes hard work, thick skin, and perseverance.

At the same time, it's not as difficult as you might think. Not if you know the secret.

Every day, hundreds of books and thousands of articles go into print. And here's the truth: Some of them aren't very good. What's the difference between published authors and you? What do *they* have that you don't? Maybe nothing. Except they know how to get published, which is actually quite significant.

Want in on the secret?

ARE YOU READY?

Before you jump into the world of publishing, you need to ask yourself a few questions:

Am I serious?

Am I committed?

Am I prepared to be challenged?

Too many people dream of one day publishing a book or getting a piece featured in a magazine without first counting the cost. It sounds kind of glamorous— getting a book published—doesn't it? It's not. I've done it a few times now, and it's more grisly than anything.

Most writers are content to dream but aren't prepared to do the work. They fail before they start. I don't want to put you through that. So before you begin, take a moment to consider what you're about to do.

Are you prepared to work? To persevere? Even when it gets hard? Even when you're discouraged or lose sight of your goals? Will you still get up each day and write?

This is what you must resolve to do. Otherwise, you're doomed from the start.

Let's be honest: You're probably not a great writer. If you are just starting out and don't have decades of publishing your work under your belt, this is a given. Which is fine as long as you don't stay there. We all start somewhere, right?

So the first thing you need to do is get better. And the best way to get good at something is to practice.

You probably already knew that, but here's the twist: The best way to practice is to do it in public.

We talked about this a little earlier, but it bears repeating. Musicians become professionals by playing a hundred live shows. Likewise, writers become authors by publishing a lot of bad work (until it's no longer bad). In fact, this is true for any creative art.

A young actor once lamented to Walter Matthau, "I'm just waiting for my big break."

Matthau laughed and replied, "Kid, it's not just one break; it's fifty."

A writing career happens iteratively, over time. You don't need to take a giant leap. You just need to take the next step. Publishing a book begins not with a manuscript but with a baby step, with practicing in public.

Where do you start? With small, gradual steps. We've talked about starting a blog. Write a guest post for a friend's website. Do a freelance gig *pro bono*. Bit by bit, you are building your portfolio before you go for the Big Kahuna.

This is the only practical way to get published. You might be able to forgo this step if you're a celebrity or heiress of a tycoon. However, for the rest of us, this will require work—honest blood, sweat, and tears.

Stop waiting for permission and prepare to do the work. *There are no big breaks.* Only tiny drips of effort that lead to waves of momentum.

WALK BEFORE YOU RUN

Before you write a book, you should write a dozen

THERE ARE NO BIG BREAKS. ONLY TINY DRIPS OF EFFORT THAT LEAD TO WAVES OF MOMENTUM.

magazine articles. Maybe more.

You should guest post on popular websites and blogs and do radio interviews. You should create a platform (i.e. a blog, a podcast, etc.) and start cultivating your fans and friends and patrons. Now.

All of this is practice for your book—for your career as a writer. The fun part is it's not practice at all. You're doing it. You're writing and publishing your work. You're developing relationships with editors and influencers. And when the time comes, publishing a book will be the next logical step.

There are five steps to getting published in magazines and other publications before you take a leap into book publishing. The first is the most important. So listen up.

STEP 1: GET YOUR FOOT IN THE DOOR

A lot of writers make a big mistake. They come up with a topic that would make a good piece for a magazine, newspaper, or website. They spend *way* too much time on the idea without ever getting feedback. They spend hours or even days writing the article. Then, they try to find someone to publish it. And they fail miserably.

Some people call this "freelancing." I call it stupidity.

This is backwards thinking. It assumes you know the audience better than the publisher does. (Even if you do, this attitude won't get you very far.)

So what's the right way to do it? Start with a few

loose ideas and contact the publisher before moving forward with the piece.

The whole point of that initial contact is to get yourself on a publisher's radar. Relationship and conversation are more important than good ideas and great writing. (At least, at first.) Instead of cold-pitching your ideas to publishers, do something better: Build a relationship.

Before you do that, though, do your homework. Study the publisher's guidelines. Read sample pitches. Email friends who have gotten their work published. Find out what works, and replicate it. You may only get one shot at this. Make it count.

Then, reach out to the editor. Present your ideas in a way that is a clear "win" for the publication. Explain how your piece will be relevant to their readership. Offer samples of other pieces you've done. Have something to show them—anything. Just don't show up empty-handed. This works for a magazine, a trade publication, or even a blog.

As it turns out, content is not king. Relationship is. Start making connections with publishers so when the ideas come, they'll pay attention to your work.

STEP 2: DON'T FALL IN LOVE WITH ONE IDEA

Many friends with book deals tell me the idea they least expected is the one publishers chose to turn into a book. The same has happened when I've published articles in magazines, on websites, and in other publications. It even happened with my first book. The

publisher picked a topic I never would've considered turning into a book.

There is an important lesson here. Publishers are in the business of selling words. They know what they can sell and what they can't. Therefore, *you don't get to decide what makes a good idea; the publisher does.*

As you build your platform and establish your authority as an author, you will earn the right to decide which ideas are good, and you'll learn where the right audiences are for those ideas. But until you do, trust the publisher. If no one will read your article, then it doesn't matter how good it is—at least not in the realm of publishing.

> *AS IT TURNS OUT, CONTENT IS NOT KING. RELATIONSHIP IS.*

Sometimes, your ideas aren't as good as you think. Other times, the world just isn't ready for them. So set your pride aside for a little while and have faith. If you have great ideas the world needs to hear, you will eventually get to share them. However, when you're just getting started, you don't get much of a say. It's best to "go low" here, to learn and serve your way into influence. Consider this a seasonal discipline; it won't last forever.

When approaching publishers, if you stay flexible about what should get published, it will make you a better writer. It will also make you a better salesperson of your ideas. (Gasp. He said "sales.")

Yep. That's right. Pitching is selling. There's no other way around it. This doesn't mean you have to slick your hair back and talk funny. It just means you need to be prepared to make your idea appealing to

the publisher. I mean, you're asking them to hire you. They're spending money on you, right? Make it worth their while. Enter their world. Think like they think.

So before you pitch, gather a few ideas you think are worth publishing. Brainstorm, taking notes as you go. Next, highlight the very best ideas (at least three of them, but no more than ten), and write an interesting headline for each. Under the headlines, write a couple of sentences, describing the potential piece.

Then, try pitching to several publications or publishers at once, following the appropriate guidelines for each. (You should thoroughly scour a website or magazine for any submission guidelines before ever submitting a piece.) Now, this doesn't mean to just blast the same idea to every publication. Most publications consider simultaneous submissions to be unethical. But you can create several different articles from a single idea.

My friend Marion used to work for the *New York Times*. She also wrote a book about Alzheimer's disease, which her mother had. She told me she probably wrote hundreds of articles based on that one story about her mom. Of course, they were all different—each one was tailored to the publication and a specific element of the story—but they had their roots in the same idea.

The idea here is to widen your chances of connecting. Keeping several irons in the fire will increase the likelihood of at least one getting published.

If you need help, here's a quick list of items every pitch needs:

• Personal salutation (use the editor's name)

• Quick introduction of yourself (if this is the first contact)

- Samples of your work (article links, document attachments, blog posts—whatever is your best work)

- List of ideas with potential titles (scan the publication to get a feel for how they write headlines)

- A concise abstract of each article (2-3 sentences)

- Closing with your contact info, including a link to your website/portfolio

Want to see how I do it? Following are three samples I've used. The first is for a magazine where I don't have a relationship yet. The second is for one where I've published before and have a relationship with the editor. The final sample is a pitch for a guest blog post where I don't yet have a relationship.

SAMPLE #1: FIRST CONTACT

Hi [First Name],

My name is Jeff Goins, and I wanted to submit an article idea for [MAGAZINE]. The premise is that people in their twenties and thirties need to travel the world.

I spent fifteen days last January with a group that is traveling for a year and saw how that's changing their lives. I'm attaching a press release I wrote to give you an idea of the experience. There are different directions we could take the article, but I think the idea is compelling for your readership.

Some ideas would be to do a Q&A with one of the travelers who just returned from a year abroad about how they are now living life. Or, I could expand upon an article I already wrote for [WEBSITE].

Another option is to make it a general call to action for young Americans to take a year off and find themselves, as so many other cultures do.

Here's another article I wrote about that: [LINK]. I could expand upon that idea.

Let me know your thoughts. If you're interested, I'd be happy to start drafting something and send it your way. Just let me know when you'd think of running it.

Thanks for your time,

Jeff Goins

goinswriter.com

SAMPLE #2: ONGOING RELATIONSHIP

Hey [First Name],

I had an idea for an article for an upcoming issue of [MAGAZINE]: My friend Paul and I traveled around the U.S. for a year after college to play music. We spent a year living in community, sleeping in people's homes, and living on nothing but the generosity of strangers.

We communicated with each other regularly, sharing our frustrations and challenges of life on the road. Sometimes, I think that's all that kept us sane.

Here are my ideas for the article:

1. A piece we would co-write, sharing highlights from our year on the road.

2. A piece about traveling, leading peers, and the importance of long-distance friendship.

3. A travelogue of a year on the road (just written by one of us).

What do you think?

Sincerely,
Jeff Goins
goinswriter.com

SAMPLE #3: GUEST BLOG POST

Hi [First Name]:

I've been following your work for a while and really appreciate what you write.

I'm working on a piece that I thought might be fitting for [BLOG]. It's called, "[ARTICLE TITLE]". It's based on something I learned from reading your blog.

The rough draft is below: [300 word article excerpt]

Are you interested in running this? If so, I'd love to develop it some more. If you'd like to see samples of my work, here's an article on my own blog: [LINK]. And here's a recent guest post I wrote: [LINK].

Thanks,

Jeff
goinswriter.com

STEP 3: DON'T WRITE THE PIECE

If this is your first foray into publishing, there's something you need to be prepared for. Something you may be dreading. Something you'd rather not do.

You're going to have to write and rewrite a lot.

For every hundred words I write (which might take about 10 minutes to spit out), I spend about 30 to 60

minutes of editing and rewriting. When I'm pitching publications, I plan for this. I schedule accordingly. You should too. (Your pace may be different; what's important is to set reasonable expectations.)

A piece that runs about 2,500 words (the length of a feature magazine article) can take me anywhere from five to 25 hours, depending on the amount of work involved and my familiarity with the topic.

When you break it down, earning a few hundred bucks per piece (when you're spending dozens of hours on it) isn't really worth the effort. *Good thing writers don't write for the money.*

What's that? You are writing for the money? Well, good luck with that.

If you aren't prepared for this arduous process, you had better go find an easier way to make a buck. Otherwise, it'll be a rude awakening when you come in contact with your first picky editor. And trust me, he's waiting for you. Red pen in hand.

So it doesn't make much sense to write the article before you pitch the piece. *Does* it? I mean, you're going to rewrite it anyway, right?

Might as well get a guarantee they're going to run the piece first (if you can). Better yet, get to know the editor's preferences and style before beginning. It'll save you a *lot* of work.

Still, I know how it goes. You'll be tempted to get started. Excitement over an idea will cause you to start writing too soon. Avoid this temptation. It will steal hours, days, and months of your life—if not more.

You will save a lot of time if you focus more on pitching than writing at the initial stages of a piece.

Focus on building relationships with publishers,

getting to know editors, and preparing to write the article. It will be worth the effort. Trust me.

STEP 4: BE PERSISTENT

Publishers and editors work hard. Most of them are bogged down by loads of submissions every day. They don't have time to remember who I am or what I wrote three weeks ago. They probably can't even remember their dog's name. But that's okay.

Because it's not on *them* to remember; it's on *me*. If I care about my writing, I need to be the one keeping the piece at the forefront of the publisher's mind. So I do them a favor by following up regularly. I check in, ask if they need anything else, and see if they're still interested. You should do the same.

There is a relational part of this job of being a writer you need to embrace—even if you're the most introverted person in the world. Email is your friend, and it's far less scary than picking up the phone. Find ways to work up the courage to network and introduce yourself to strangers. Depending on your personality,

> *IT'S NOT ON THEM TO REMEMBER; IT'S ON ME. IF I CARE ABOUT MY WRITING, I NEED TO BE THE ONE KEEPING THE PIECE AT THE FOREFRONT OF THE PUBLISHER'S MIND.*

it can be very hard. But it's also worth the awkwardness and discomfort.

This is one of the secrets to prolific publishing: *being connected with the right people at the right time*. It's not

exactly fair and may not be what you signed up for, but it's how the world works. Learn to live with it. Or stop complaining that your work doesn't get published. There is no in-between.

Think of it as the process you follow after interviewing for a job. You want to stay in the mix, and you don't want to be forgotten. So you check in just to see how things are going.

Same deal here.

So how do you do this without being a pest?

When you're expecting to hear back on a submission, checking in weekly (as long as the publisher hasn't told you not to) is a good way to stay at the forefront of the editor's mind. A good way to do this and not be annoying is to ask what they thought and offer to rewrite the piece, if necessary. Be cordial and polite, but don't apologize.

Let the editor know other publications may also be considering a piece based on the idea (only do this if it's true). This will put a little pressure on them to make a decision and will let them know your work is in demand. You can also ask what their typical response time is. For most magazines, the standard is four to six weeks. Websites are often faster.

If you don't hear back in a month or so, they probably aren't going to publish your piece. This is a generality based on my experience. Always defer to the publisher's submission process and guidelines if they define their own timelines. Every place is different, but it's not unusual for it to take a while. This is why it's always good to have a few submissions going (for similar ideas).

Even if following up is a little uncomfortable, this

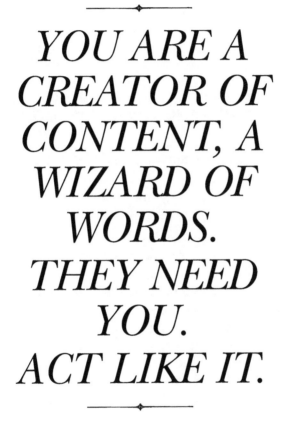

YOU ARE A CREATOR OF CONTENT, A WIZARD OF WORDS. THEY NEED YOU. ACT LIKE IT.

is better than the alternative—waiting for them to pick you. It puts you at the helm, which is where you belong.

You are a creator of content, a wizard of words. They need you. Act like it.

And if you decide to publish your piece with another publication (because you've waited several weeks and haven't heard back), it's courteous to email the publisher. Let them know you've decided to take the piece elsewhere.

WHEN THE ANSWER IS "NO."

Now, to this point, we've assumed your idea is still in the running.

But you'll hear no. You'll hear it more than you want to. Every writer does.

Stephen King kept his early rejection letters stuck to a nail above his writing desk in the attic. When the nail couldn't hold all of them, he replaced it with a spike and kept submitting. Kurt Vonnegut kept his rejections in a candy box.

So you'll be in good company. And when you're pitching, when you hear that "no," there is one cardinal rule you should never break. I'm a little hesitant to share it, because I don't want you to get the wrong idea. I don't want this to be an excuse to back down or sabotage yourself. But this point is too important not to share.

There's one thing you absolutely must not do. Ever. And it seems counter to my point of being persistent, but listen up: *Don't keep following up after they've told you no.*

This is not playing hard-to-get. If they've told you

they're not going to use the piece, don't try to convince them otherwise. Don't beg for another chance. You are only wasting your time and living in denial. Time to move on before you burn a valuable relationship.

Which raises another point: Sometimes, "no" is really "not now." Don't confuse the difference. If an editor *says* she wants to work with you again, she means it.

STEP 5: BUILD LONG-TERM RELATIONSHIPS

Wherever possible, build strong relationships. A publisher is not a person, but an editor is. Get to know these people; make their jobs easy. They are your greatest allies. Build a relationship, and maintain it. Why keep starting over? The hard work is done; now, it's time to benefit.

Once you have your foot in the door with a particular editor, it's much easier to get a second or third piece published. Capitalize on that. Write multiple pieces for places that have previously published you.

Typically, I write a few times for each publisher I work with. Why not? Once you get to know them and what they expect, it's pretty easy to keep writing for them. And you usually don't have to worry as much about pitching.

The hardest part is the front end—figuring out what publishers want and getting them to notice you. Once you're in, you're in. Milk it for all it's worth.

One quick note (and this is important): Make this a relational transaction, not just a business one. Under-promise and over-deliver, and you'll never have to go

looking for work again. This means accept feedback gracefully, do great work, and deliver your piece on time.

If you do this right, don't be surprised if an editor comes to you on occasion, asking you to write a piece. Once your foot's in the door, it's there to stay (unless you really mess something up).

And on that note...once you're in, don't mess things up.

Most importantly, never burn an editor. Read that sentence again. Never. Ever. Burn. An. Editor. It's important.

I wrote a piece for a website a while back, and they wanted to change some of my content (which is typical). However, there was one phrase I was adamant about leaving in, and they wanted to cut it. I resisted. (That's a nice way of saying I pitched a fit.) I emailed a writer friend, saying, "Can you believe this! The nerve. What should I do?"

She gave me some tough love: "Do what the editor says. You have a gift: someone who is willing to work with you. Trust her. There's nothing like a good relationship with an editor."

My friend was right. Not only does deferring to the editor help your relationship, but you also never know what will happen to these people—where they will go and what they will do. Make friends, not enemies, with editors.

Yes, there will be conflict. Yes, they will frustrate you and want to change your words. But these people are a gift. Their job is to make you better. So when you find an editor you like working with, be nice to them.

This is a relational business. Always be looking for networking possibilities so you can have more

opportunities to write and get published in the future.

By the way, a final note on your relationships with editors. It is acceptable to ask editors for endorsements and referrals for other writing gigs. Just realize this is a "withdrawal" from your trust bank. Make sure you've made enough "deposits" before making a request like this. If you've wowed them enough times, they'll be happy to help you out.

REVIEW

Let's recap.

The most important concept is this: *If you can learn to pitch well, you'll get an article published.* The rest is details.

Publishing is about more than having the right ideas; it's about having the right connections. It's an art, so be willing to dance a little. (Pardon the mixed metaphor.)

Keep persistently pitching and try not to get discouraged.

Learn to embrace the relational aspects of the business, and you'll find the right outlets for your message.

Remember: This is about forming relationships as much as it is about creating content.

PUBLISHING IS ABOUT MORE THAN HAVING THE RIGHT IDEAS; IT'S ABOUT HAVING THE RIGHT CONNECTIONS.

ELEVEN:

WHEN THE
PITCHING ENDS

———◆———

Of course, all of this might seem silly. After all, every writer's dream is to not pitch a single piece, to never have to sell yourself. Right? But the reality is—one way or the other—you're going to have to do a little selling. At least temporarily.

You'll have to knock on doors, email bloggers, and ask for guest post opportunities.

You'll have to introduce yourself to agents and publishers before you get a book deal.

You'll have to befriend editors and pitch like crazy to get a piece published.

You'll have to send a few query letters and contact people you'd prefer would just ask *you*.

But all of this is preparation. The truth is you won't always have to do this. Not if you're good. One day,

you'll be the gatekeeper. The publishers will come to you.

The paradox, though, is if you *are* good—and wise—you will do this anyway. Even when you don't have to.

AFTER YOU'VE ARRIVED

Every diligent writer eventually reaches a point he never thought he'd reach. This will happen to you, I'm confident of it. You may become well known in your niche or finally publish a book or end up on *The Today Show* or *New York Times* Best Seller list.

Every writer has a moment of "arriving." You end up on top of the world (even if it's a small world). You do something you never imagined. This will happen if you do your work. But what then?

Well, you have a choice:

1. You can settle with what you've achieved, or

2. You can keep reaching out, keep challenging yourself, keep growing.

(Hint: Opt for the latter.)

Every milestone affords a new vantage point. You realize how much there is left to explore.

The trick here is to learn to be content with the journey, because you never *fully* arrive. However, the true masters of the craft are those who never grow complacent. They're never fully satisfied; they're always pushing themselves a little further.

Hear me loud and clear. I'm not advocating for being a workaholic and ditching your family and

friends for a writing career. What I am saying is this: You can always get better. Do yourself (and your readers) a favor and remember it.

Don't get cocky when you see success. You're not as big of a deal as you feel. And the feeling fades. What remains is the eternal joy of getting to do work you love.

DEATH OF A SALESMAN

The fun part, of course, comes when you don't *have* to pitch your work anymore. When you can finally stop selling yourself because you need to, and when you can pursue ideas because you want to.

If you choose yourself, build a platform, and always ship your best work, this is within your reach. It may take time, but it will happen. It all begins with having the courage to ask. To make a few phone calls, send a couple of emails, or even ask someone to coffee.

If you do this, I promise you a day will come (maybe sooner than you realize) when the editors will come to you, asking you for work. They'll want to pull an article off your blog or have you do a feature piece for an upcoming issue. They'll want to partner with you to reach an audience. You will publish books and share your ideas with the world. And the dream will become a reality.

Until then, keep working. Keep writing. Keep showing up.

ALWAYS DO THE BEST WORK YOU CAN FOR LESS THAN YOU DESERVE (YES, YOU HEARD ME). BECAUSE FREELANCE WRITING IS NOT JUST FEE-FOR-SERVICE WORK. IT'S MARKETING.

Piecework is platform-building. One piece at a time, you are building a legacy. A brand. A reputation. It's worth a little sacrifice, a little sweat. Isn't it? By all means, don't go hungry. But don't make this all about dollars and cents. It's a marathon, not a sprint. And those who win treat it as such. Drip by drip. Persevering 'til the end.

See you at the finish line.

Fin.

(We're done here. Now, go do something that matters.)

WHAT NEXT?

Well, that's up to you.

I'm sure this book raised as many questions as it provided answers. That was the point. (Sneaky, huh?)

But I don't want to leave you in the dark. This was, in many ways, an introduction to a conversation I hope continues. Plus, I'd love to hear what you thought:

- What questions do you still have?

- What do you need help with?

- What did I miss?

I'd love to continue helping you in your journey of picking yourself. Of finding your own path, spreading your ideas, and seeing your words in print.

You can tell me what you thought of this book and/ or share it with your friends by visiting this website: youareawriter.com. Or, you can join the discussion on Twitter: *#youareawriter*

If you'd like to continue this journey further, check out an online writing course I started at TribeWriters. com. The course only opens a few times a year, but you can sign up to be notified the next time an enrollment comes up.

If you have questions, you can find how to connect with me below.

By the way, *thanks*. You didn't have to read this book, but you did. I appreciate your sticking with me to the end. That says something about you already.

We writers have never seen a time like the day in which we now live. I hope you take advantage of it.

Remember: You *are* a writer. You just need to write.

ABOUT THE AUTHOR

Jeff Goins is a writer, speaker, and communicator. He believes words can change the world and that brownies are the world's best breakfast food.

He has contributed to various publications and blogs, including *RELEVANT Magazine*, *Copyblogger*, *Problogger*, and *Zen Habits* (voted by *TIME Magazine* as one of the top 50 websites of 2008).

Jeff lives in Nashville with his wife, his son, and his dog. He secured office space to force himself to get out of his pajamas and interact with humans.

To connect with Jeff, visit him at any of the following:

Email: jeff@goinswriter.com

Blog: goinswriter.com

Facebook: facebook.com/goinswriter

Twitter: twitter.com/jeffgoins

———————◆———————

TIME TO CHOOSE YOURSELF.

START CREATING.

———————◆———————

Find the Audience Your Message Deserves.

Get a free lesson at
Tribewriters.com

Tribe Writers

CPSIA information can be obtained
at www.ICGtesting.com
Printed in the USA
BVHW030216271018
531317BV00002B/4/P